REFLECTIONS

REFLECTIONS

DAVID ROBINSON

With a Foreword by
Ernst Haas

HOLT, RINEHART AND WINSTON / NEW YORK

Published simultaneously in Canada by Holt, Rinehart and Winston of
Canada, Limited.

Library of Congress Cataloging in Publication Data
Robinson, David, 1936–
 Reflections.
 1. Photography, Artistic. I. Title.
TR654.R66 1978 779′.092′4 78-4700
ISBN Hardbound: 0-03-042711-8
ISBN Paperback: 0-03-042706-1

First Edition

Designer: Linda Schwartz
Printed in Great Britain

To Carol and
to Alexandra

Foreword

Man is a mirror. He reflects reality as well as himself. There exists a strange relationship between the mental and the physical phase of the phenomenon called reflection. In the dictionary, the definition of *reflection* is divided into mental and visual applications. But when experienced by man in the creative process, the word reflection merges both meanings.

All our senses are nothing more than mirrors that echo the world in such a way as to feed the mind and allow man to reflect upon that world. Dreams as well as meditations are based on conscious and unconscious qualities of reflected perceptions.

As this is a foreword to a book of reflective images by a talented photographer, I want to abandon all intellectual theories and concentrate on praxis and results. I have my own almost lifelong fascination for photographing reflections. What makes the difference between photographing normal, as opposed to reflective, images is the challenge to photograph suddenly not only in one direction, but also forward and backward simultaneously. One is forced to compose both possibilities as a totality—as David Robinson has done in this book so often and so well. Concentration for such pictures needs a special awareness: One has to deal with two, three, or even more visual layers.

The photographer has to compose in such a way that the picture creates an almost new order out of the ever changing chaos of nuances in color and form, instead of sandwiching pictures on top of each other—as is often done for the sake of an obscuring effect—to make two bad pictures into one good one.

Like mirages in the desert, reflections stimulate one's thirst for more and better pictures. But you must know how to find them. I will never forget the lines of my favorite German poet, Rainer Maria Rilke, in one of his famous sonnets: "*Wenn auch die Spiegelung in Teich dir of verschwimmet, wisse das Bild.*" Poetry loses in translation, but basically this means: "Even if the reflection in the pool gets blurred, the picture you have seen will reappear." The idea is appropriate for those many sensitive situations the photographer encounters almost as an intruder. To photograph a special reflection in a pool forces the photographer to "step into" the water, but by doing so he blurs the image he had in mind. Yet patiently standing still will clear the water, and slowly the picture will reappear.

Reflections in everyday life are more a hindrance to vision than an advantage because most people don't live for aesthetics. To turn reflection into an advantage in the visual field requires great concentration and a special eye.

David told me, as he tells the reader in his introduction, that he remembers exactly when, for the first time, he was fascinated by a reflection as photographic image, a street puddle reflecting the tower of a church. After that experience he was captivated by the wonderment of reflections.

The purely obvious mirror picture, with its exact double image, is almost too easy, and David avoided it carefully. The magic of his images lies in their impressionistic, multi-dimensional, and enigmatic quality. His aim was not to depict concrete facts or critical opinions about a foreign land, but rather to show the fragmented imagination of a photographer turned into a walking dreamer with lyrical feelings and open eyes.

The first victim of his own reflection was Narcissus, who saw himself in a spring, fell in love with his image, and drowned. There are other ways to see oneself without drowning. In reflective meditation the mind becomes a mirror and we can find ourselves. Through the camera we finally are the mirror, because we can only see what we are. And now I only hope that through these photographs, you will be inspired to learn how to reflect on reflections.

Ernst Haas

Acknowledgments

I would like to extend my thanks to the following people for major contributions and support without which this series of photographs would never have been created, exhibited, or published: to my parents of course for keeping faith; to early friends, Evan Kemp who accompanied me on my first trip to Europe, Garfield DeMarco for introducing me to Italy and sharing his enthusiasm, and Serghiev for his vision and inspiration; to Ruth MacDonald for her early encouragement in Africa and continuing support through the years; to Jim and Joan Mullen and David Bakalar for their interest in my work, critical advice, and practical support; to Anthony Burgess for his novel *Beard's Roman Women*, written partially in response to these reflections and illustrated with some of them; to fellow photographer Mario Samarughi for his help in Rome; to Al and Irving at Boris Color Lab in Boston where all my dye transfers are printed; to my warm and enthusiastic agent, Bertha Klausner; to Don Hutter at Holt, Rinehart and Winston and Tom Rosenthal at Martin Secker & Warburg for working so hard to help shape the conception of this book; and to Carol and Alexandra Nordlinger for putting up with both me and my absences during the years it took to do this work. To them and to all the others whose warm response to my work has been so sustaining, I offer my sincere appreciation.

Introduction

Every photograph is an abstraction, no matter how realistic it may appear to be. Traditionally, photography has been valued primarily for its truthfulness—its ability to "capture" reality, objectively document events, "freeze" moments in time. But photography is more. As Susan Sontag points out in *On Photography*, ". . . in the situations in which most people use photographs, their value as information is of the same order as fiction." Once we recognize the inherently abstract nature of photography, we can learn to evaluate photographs not only for the information they provide but also for the emotions they provoke.

The academic debate about whether photography is art, as generally phrased, strikes me as off the mark. Critically one can neither exclude nor enshrine an entire medium. The real task for those who wish to debate art and photography seems to me to be the development of aesthetic criteria by which to evaluate photography. What makes a photograph (or anything else) a work of art depends on the individual and aggregate response to it over time, and in the flux of critical standards and popular taste, fashionable prejudice often seems to be the only constant. Thus I am not interested in any attempts to establish rigid, judgmental categories, but rather in developing criteria for deeper appreciation. I am less concerned with evaluating photo-graphic results in terms of the process than I am with exploring aesthetics common to photography and other art forms, especially painting and motion pictures. Whether the photographs in this book suggest paintings, collages, or movie stills, or how they were produced, really is no longer relevant. The fact that people commonly refer to them as "paintings" is not so much flattering as reassuring—reassuring that photographs can be viewed according to criteria applicable to other art forms as well, regardless of origin.

For some time, I have been interested in using the photographic medium not to attempt to re-create reality but to fuse images originating in the physical world with the viewer's imagination. I want each photograph to provide a different experience for each viewer, depending on what is brought to the photograph. (And hopefully the photograph will keep changing for each person.) Although Susan Sontag asserts that the identification of a photograph's subject—as opposed to that of a painting—dominates our perception of the photograph, I don't regard this limitation as inherent in the medium but rather the result of inexperienced and unimaginative viewing. Motion pictures have been able to transcend the bias in favor of reality, and I see no reason why photography cannot also. This potential is tremendously exciting for me, for it so greatly

expands the possibilities of photography. I do not expect my photographs to be *momenti mori*; I want them to breathe.

What I look for is not so much realistic or representative subjects as images that are fertile, having the potential to grow and become something else. Like Aaron Siskind and Clarence John Laughlin, I want my photographs to be entirely new entities. But we must recognize (unless perhaps we become totally abstract with noncamera processes) that even in creating new entities, we must still use as basic raw materials visible parts of the physical world. One part of the creation remains linked to what was previously recognizable. The photographer's camera eye acts as something like an umbilical cord carrying life from the original subject to the new images, allowing them then to sustain themselves. In Jean Renoir's words, "Reality may be very interesting, but a work of art must be a creation. . . . Reality is merely the springboard for the artist."

The photographs in this series were all taken in Italy and owe their inspiration to Italian subjects. Yet they travel well, and identifying them should not be limited to where and when they were taken, nor to what was photographed. Their value is not in what they once were but in what they have become. What is important is the emotion transmitted.

I photograph best when I have no plan, no preconceptions, no self-imposed limits, when I am not in search of any particular thing. I am more at home in the street than in the studio. I like to keep walking, to become part of the pace and swirl of activity around me. I don't necessarily know where I am going, and certainly not where I am going to end up. I value the unexpected and try to remain open to anything, to be eclectic but not random or scattershot. I always try to measure what is by what it can become. Of course, part of the mystery of photographic creation is that sometimes what is revealed is more than what you were conscious of during the shooting. As Sergei Eisenstein put it with regard to film: "The filmed material at the moment of editing can sometimes be wiser than author or director." Perhaps previsualization is partly unconscious.

Ansel Adams is fond of saying that chance favors the prepared mind. For any photographer, that preparation involves experience and discipline, but for me, in addition, it is a question of mood. I need to be totally absorbed in seeing, relaxed yet alert, a state Aldous Huxley has called "dynamic relaxation." If this does not seem possible, I would rather leave my camera at home and content myself with the mental images I am constantly taking wherever I go. So I am not prolific; I photograph intermittently.

Part of the attraction of Italy is that there I am able to be both relaxed and inspired. I knew Italy well even before I began photographing there, and I had the good fortune to be introduced to her by two of her most affectionate sons— Garfield DeMarco, a college friend whom I visited in Naples where he was studying and who took me throughout the back streets, his family's village in Calabria, and to the small and ancient towns of Sicily. Later, when I returned to Rome, an artist friend who goes by the name Serghiev, provided me with an entirely new view of the city's streets, people, and art. I benefited from the insights of both friends, absorbed their affection, and came to feel completely comfortable there.

Italy not only inspires but continually rewards the aesthetic mind. Its attraction helped separate me from all other concerns and allowed me to become totally engrossed in seeing and creating, to attain my own state of "dynamic relaxation."

One day while walking through Rome's Piazza Navona after a rainstorm, reflections from the puddles between the cobblestones flickered at my feet, dreamlike visions thrusting themselves upon my consciousness. As I walked, I caught fleeting images of people, fountains, and buildings passing among the cobbles. I was attracted to the

irregularly framed images, the shadowy figures, and the impressionistic upside-down views of my surroundings. The intrigue of reflections overtook me, and so strongly that it was in the nature of a momentous discovery. A new world was suddenly opened up to me from among the familiar.

I decided to experiment to see how these reflections could be photographed, and to explore the potentials released by this new world. I now moved through the Piazza differently, stalking images the way a hunter looks for tracks. What I found excited me, and in the next few weeks I began to look at Rome differently, literally through its streets.

Before this I had been working on two series that sought to expand the boundaries of conventional photographic composition. The first was a yoga series taken with high-contrast copy film and printed from Kodalith positives so that the images became abstract silhouettes barely relatable to the human figure. The second was a series of allegorical photographs—manipulated multi-layered photo-collages using double imagery, solarization, nonphotographic materials, and magazine transfers. The borders were cut to become part of the composition, not merely its container. So when I discovered reflections—or when they discovered me—I was prepared. And despite what Susan Sontag says about "unbridgeable gaps between one period and another in a large body of work, confounding signature," I can trace a distinct path of common aesthetic concerns and styles from my yoga photographs and manipulated collages to my reflections. In photographing reflections, I found a natural, camera-contained way to carry on these interests and a new source of imagery richer and more varied than my previous constructivist pursuits.

After some initial experimentation, I decided to work exclusively in color for this series. For one thing, I feel color more deeply than black-and-white. It carries more emotion for me. I find color romantic and mysterious, calming and provocative. Only color seemed to be able to convey both the richness and the subtlety of reflected images, from the bold and graphic to muted juxtapositions.

Color, however, can be dangerous. There is a tendency to associate color photography with its most common usage, commercial product-oriented shots or amateur snapshots. For this reason, many who warmly embrace black-and-white photographs have a hard time accepting color. (Past criticism concerning the quality and permanence of color prints has been rendered irrelevant by the new advances in technology, especially the dye-transfer process which I use for all my exhibition prints.) Also, color as commonly used does tend to overwhelm the subject or render it superficial, resulting more often than not in what I call "quick-read" photographs, those of high but only fleeting impact. But this superficiality is not inherent in the nature of color, only in the way it is commonly used. The currently popular formalist photographers themselves use color as a radical challenge to photography's traditional purposes. They emphasize their concern with form or color or the peculiarities of camera vision by presenting photographs of stark, banal, or minimal subjects, devoid of any intrinsic meaning. Most of this work seems to me overly contrived, emotionless, and impenetrable—and therefore just as fleeting as the quick-read photographs. I am too romantic to feel that the emphasis of form or use of color or revelation of vision must be at the expense of aesthetic imagery. My use of color in this series is an integral part of my imagery, crucial to the emotions and fantasies I am trying to create.

As my interest in reflections continued, I turned my attention from streets to other sources of reflected images—to windows, automobiles, and mirrors, more obvious perhaps, but still stimulating to my creative fantasies. And I looked for new locales to broaden my vision.

During the next three years, I made seven trips to Italy, traveling from Venice to Sicily in pursuit of my reflections,

each time pushing the concept further, discovering new sources, learning better how to photograph them, and all the while trying to shape a varied but coherent series. These trips I kept free of any commercial encumbrances. The photographs they produced were for me alone, my personal assignment and private world.

I realize now that I am not the first to notice or photograph reflections. They are present in other photographers' work—Atget's store windows, Brassai's nightclubs, Kertez's street scenes and distortions, Haas's New York scenes, and in films such as Eisenstein's *Strike* and Welles's *The Lady from Shanghai*. These are among the best and most obvious. And recently, reflections seem to be turning up in advertising—what Tom Wolfe calls the "knock off"—and even in television filming. But I wasn't conscious of all this when I made my own discovery.

If there is a difference between my reflections and those of other photographers, it is that for others reflections have represented one type of subject (whether important or incidental) among many that interested the photographer. (Only Kertez seems to have become seriously involved with pushing the concept, and only with his specialized series of distortions.) However, I seek to use reflections as a new medium, a new way of seeing, a new way of creating.

The more I study reflections, the more I feel—without any solid evidence—that consciously or unconsciously, reflections must have exerted a considerable influence on the development of modern art. The revolutionary vision of the impressionist painters strikes me as traceable to reflections. The similarities between the qualities of light, color and image diffusion, which I see in water reflections and the impressionist style of painting, no matter what the subject, suggest to me that this style is due in part to astute observations of reflections (Monet's water lilies are just one obvious example). In the same way, the overwhelming similarities between cubism and window reflections suggest to me that the cubists, who certainly must have noticed reflections around them, must also have received some inspiration later incorporated into their work. And despite Susan Sontag's claim that photographers do not draw from art, my knowledge of impressionism and cubism—as limited as it may be—did nonetheless condition my response to reflections and the way in which I chose to photograph them.

The more involved I became with reflections, the more ubiquitous they became for me, even while remaining invisible for most others. It seemed a special privilege had been bestowed. Yet the reflections I photographed are available to anyone. I used no special camera or lenses, no special film or processing, no manipulation such as double exposure or sandwiched images; in short, no tricks. Photographing these reflections was not a matter of technology or equipment but of perceptive vision. It seems that somehow we have been taught to filter out reflections, to look right through a door or windowpane and ignore its very existence. For normal vision, the eye merely scans the familiar. Thus the more familiar our world becomes, the more routinely we see it, and the more we miss, the more atrophied our vision becomes—until something shakes us out of this pattern.

People who have seen this work tell me they have consequently begun to notice not only reflections but everything around them in greater detail—to become reacquainted with their environment. Once we break out of the downward spiral of routine vision and begin actively to see, the world around us becomes much fuller.

Biographies of artists are usually full of historical determinants—family environment, seminal events at crucial stages, influential teachers, mystical transformations, etc.—which can be easily identified and assumed to have influenced the artist's development. (Of course in

photography there is no long apprenticeship or rigorous training necessary; one can just begin as I did, and once you begin, the medium seduces you with immediate rewards.) I never studied art formally, not even art history. Nor have I studied photography formally except to learn basic darkroom techniques. How then did I become a photographer—and more importantly, how did I learn to see the way I do?

My photography began on a conscious level in Africa—with no expectation of my becoming a photographer. I had been a student at the University of Ghana for a year and had written articles on the experience but had had to use inadequate snapshots of mine and others for illustration. After another year of African Studies at Boston University I returned to Africa as a teacher in Nigeria, and this time I was determined to take a good camera with which to record my experiences. A photographer I consulted gave me a list of equipment, which I ordered without question, and thus I arrived in Nigeria with a Nikon I didn't know how to operate. Through experimentation, I gradually learned how to use the equipment—the same camera and lenses I used for this reflections series. It was the response to my African photographs, the enthusiasm and encouragement of my friends, that first planted in me the idea of becoming a full-time photographer. But it was an idea I resisted for a long time, pushed into the background while I completed my academic work in African studies and then in education. Intermittently, I continued to photograph and was able to take a basic photography course at Harvard's Carpenter Center while studying at the Graduate School of Education.

I had embarked on my doctoral dissertation at Harvard and had begun working as a planning consultant for the Boston public schools. I had also begun renovating a mid-nineteenth-century townhouse, which became so complicated and time-consuming that in order to finish the house, I had to drop out of Harvard and quit my job. Then when the house was completed, I was left with no commitments and plenty of time and studio space. It was at that point that I decided to concentrate on my photography. With the help of one of my good friends who had been so encouraging years before, I began working as a photographer in curriculum-development projects.

And entirely by chance, within a month of my decision to become a photographer, I met the Italian artist Serghiev, who had just arrived in Boston. We became friends and formed a collaboration that has had a lasting influence on my work. Through him I became attuned to the abstract and symbolic potential of photography. I began to move my work away from literalness and representation toward more abstract and provocative images less tied to time and place. The scale and purpose of my work changed; I began to work with larger prints, some mural size, and for public display as well as for private collection. We did a series of joint exhibitions in the Boston area, and later, after he returned to Rome, he was able to arrange a show for me there. More importantly, he reintroduced me to Rome through his unique vision so that I began to see for myself the streets, people, and art with new meaning and awareness. It was while in Rome for that first show that I discovered my reflections.

But I am more intrigued with trying to identify the early unconscious determinants, for I grew up in a family that didn't value art (one somber lithograph was the extent of the art in our house). Ohio in the mid-1950s ridiculed any display of artistic talent, and I went through college with hardly a thought about art—not to mention photography.

The prerequisite or common denominator for all artists would seem to be a special visual awareness (true also for writers and poets). If so, how is this awareness stimulated; what contributes to it? One of my most vivid memories from childhood is of light shows in my head at night before I went

to sleep. They are indescribable. No fireworks, no constructed light shows or works of art have ever come close to these natural phenomena, which a doctor friend tells me are called "phosphenes" and which have been described in *Scientific American* as "subjective images resulting from self-illumination." Pulsating colors radiated out from right behind my eyes—wild, psychedelic, moving in and out from one another. My nightly childhood entertainment.

Another strong memory of childhood visual stimulus is sunlight streaming in through the windows as I played on an old oriental rug. Looking up at the bright light slicing the room into sections, I can remember being enthralled with the swirling dust particles that filled the shafts of sunlight. The world seemed very strange. The air around me was filled with invisible life, only rarely glimpsed. A different daytime show.

Television was not a factor. My family prided itself on not having a set until I was well into high school. Mine was one of the last generations not to be shaped by early exposure to television. I'm not sure whether this is good or bad, but in any case, I went to college, supposedly having received the bulk of my information through the traditional word-oriented processes.

Of course, most of our memory is visual or associated with visual images, so it's hard to separate visual stimulus from visual memory. Yet I can also remember a ritual based on fantasy and imagination that held a strong visual component for me. It was inspired by my reading Clarence Day's *Life with Father*. In the book, Father is an efficiency expert who constantly, compulsively, subdivides every activity into steps and analyzes each component according to time and energy expended. One of my childhood rituals became imitating this type of motion dissection. I closely observed every action of mine and others. Nothing was taken for granted, everything was chronicled.

Another childhood activity was pretending I was blind and learning how to navigate myself throughout the house with my eyes shut. This of course meant learning how to see better.

My first real exposure to photography came during World War II when, full of patriotism and fantasy, I collected large newspaper photographs of American generals and actively involved myself in their victories. (I was two days shy of five when Pearl Harbor was attacked.) Later—I don't remember at what age—I somehow acquired three volumes (out of four) of war photographs, which had a profound and lasting effect on me. I studied them for hours, for years, trying to deal with death, human suffering, and all the issues raised by war. These volumes became a visual dictionary of war for me, and I memorized many of the images unconsciously from repeated viewing. I know I also pondered how the photographs were taken, how the photographers escaped what they photographed (many didn't), and what was happening at that same moment outside the frame of the picture or at the next moment within the frame—questions that I now realize as a nascent curiosity about the process of photography, but that were then only part of the mystery released by these volumes.

Obviously I can't answer exactly why I became a photographer, or why I photograph the way I do. How we as individuals see, and why we see what we do, will probably always remain a mystery. But at least I can offer the photographs in this series as some evidence of a sustained personal vision. And I can only hope that seeing them will provoke your own imagination and awareness. Susan Sontag writes, "Photographs which cannot themselves explain anything are inexhaustible invitations to deduction, speculation, and fantasy." It is now up to you to complete what I have begun.

David Robinson
Boston, Massachusetts
March 1978

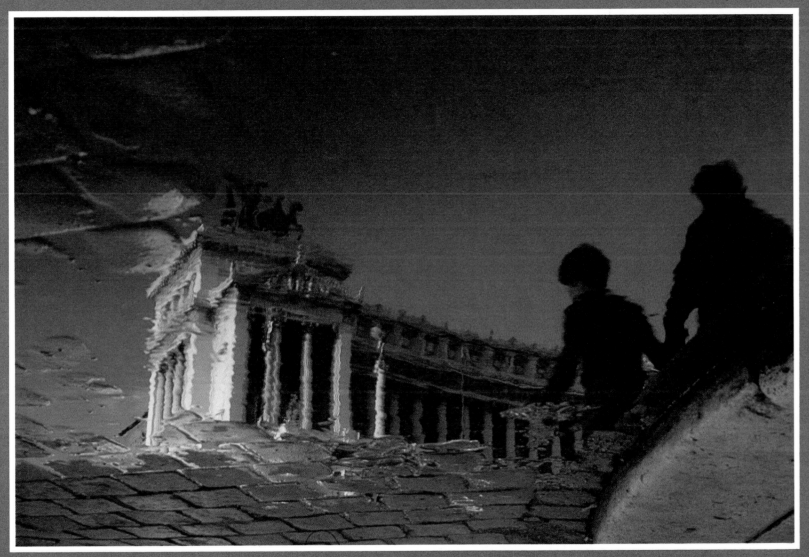

I

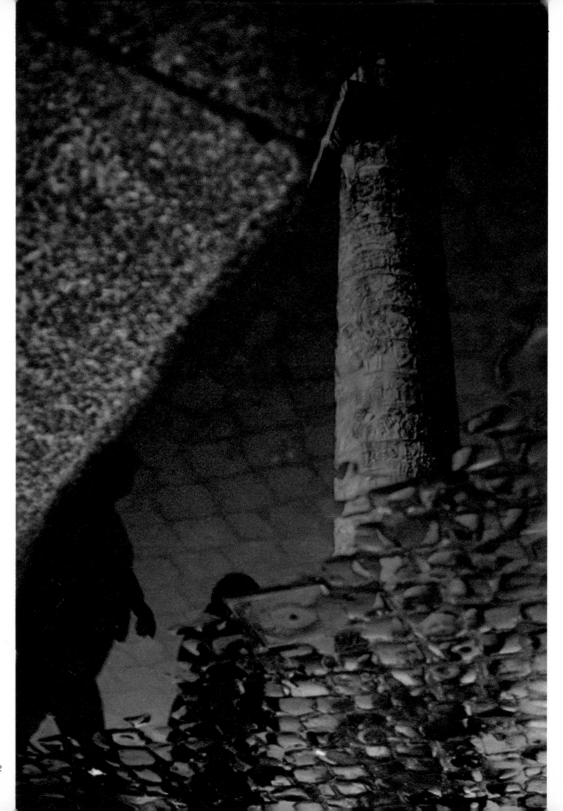

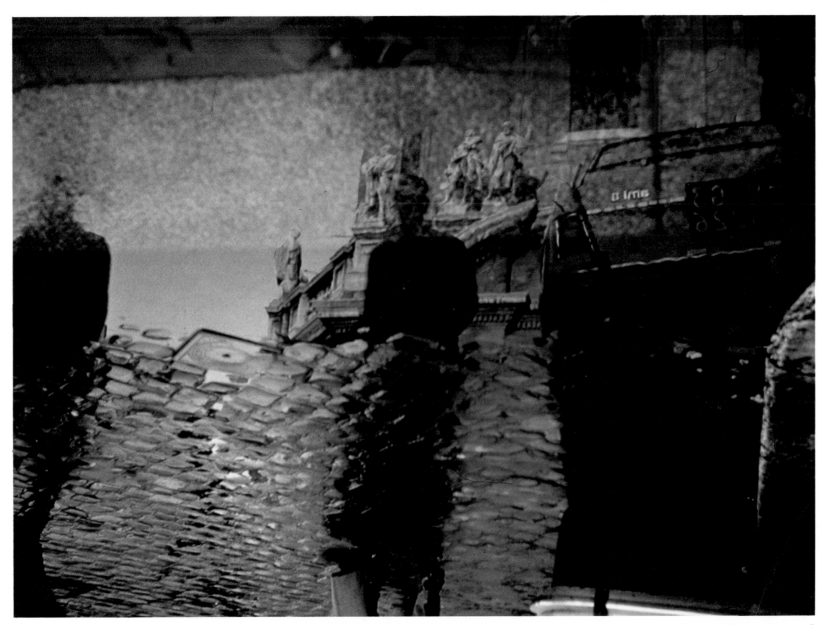

3

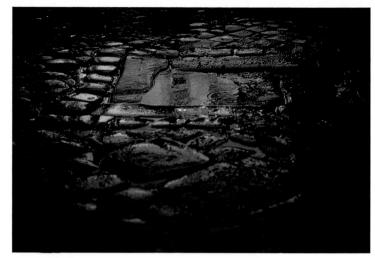

5

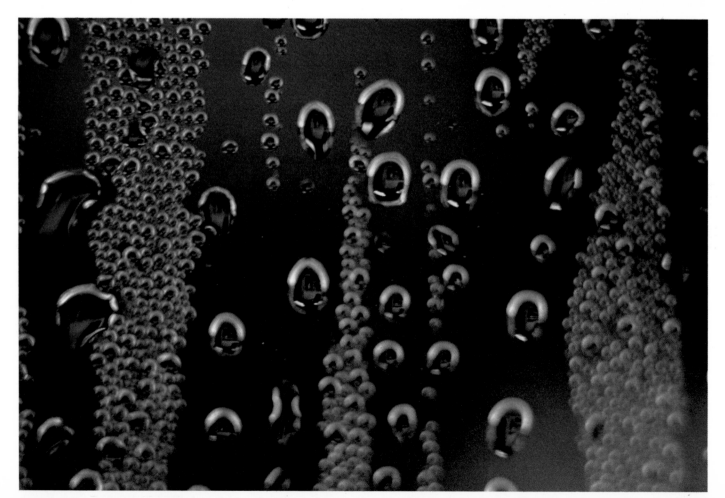

4

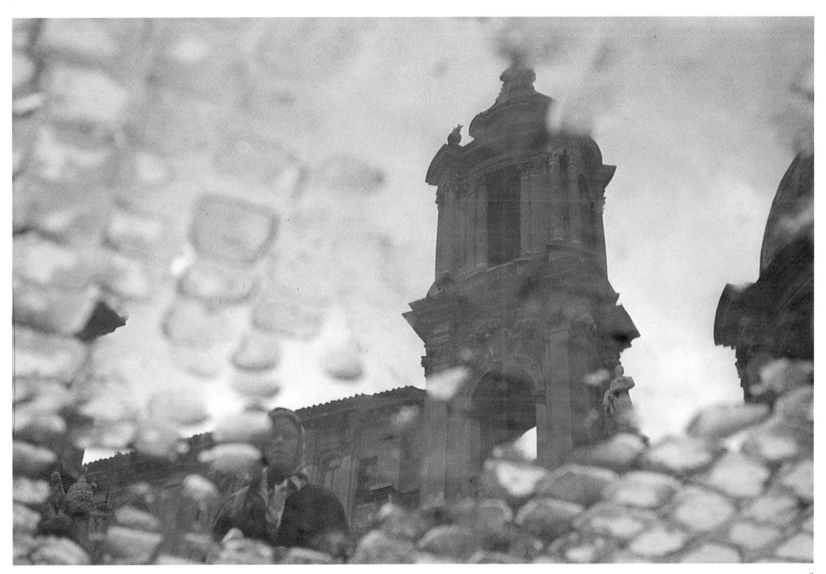

6

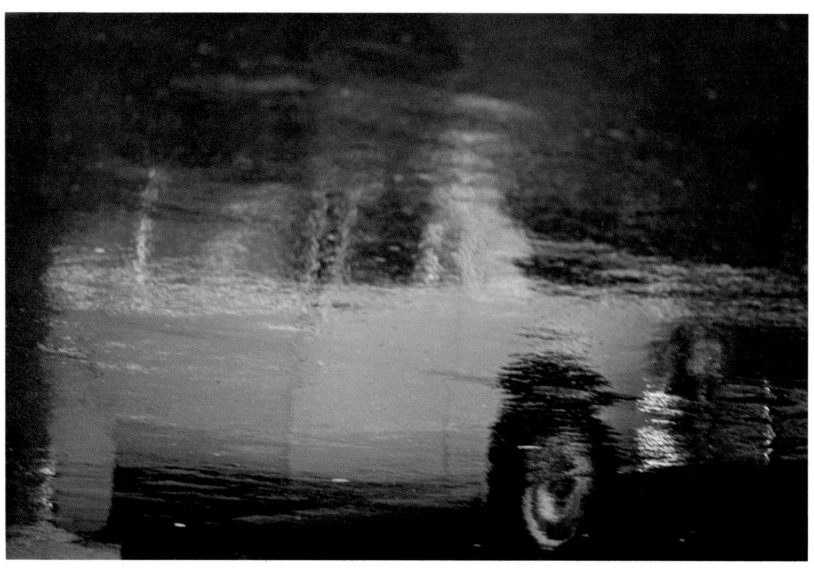

7

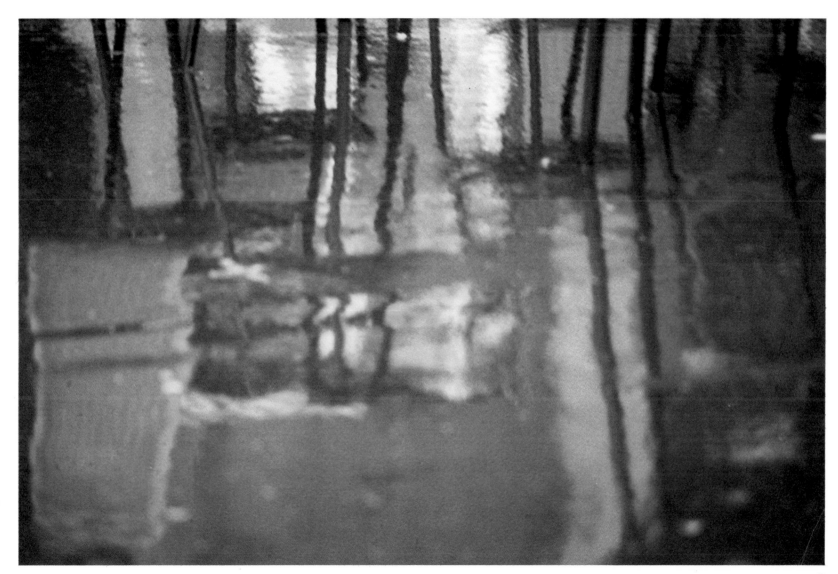

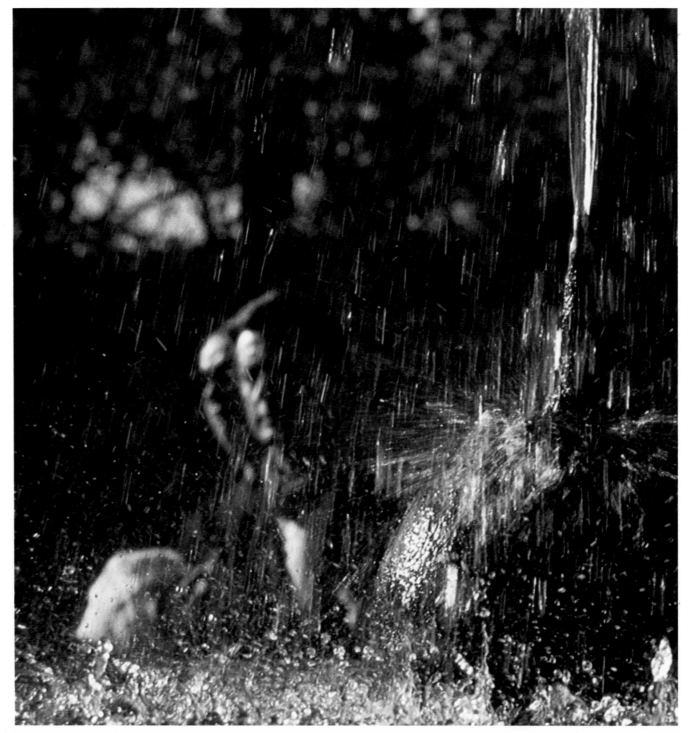

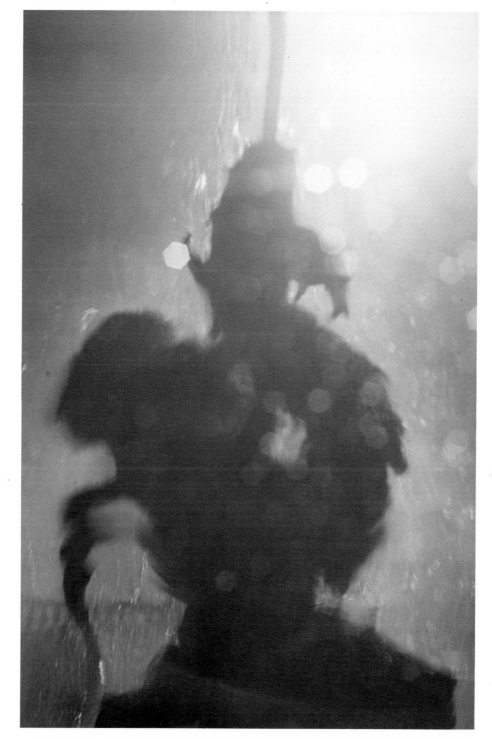

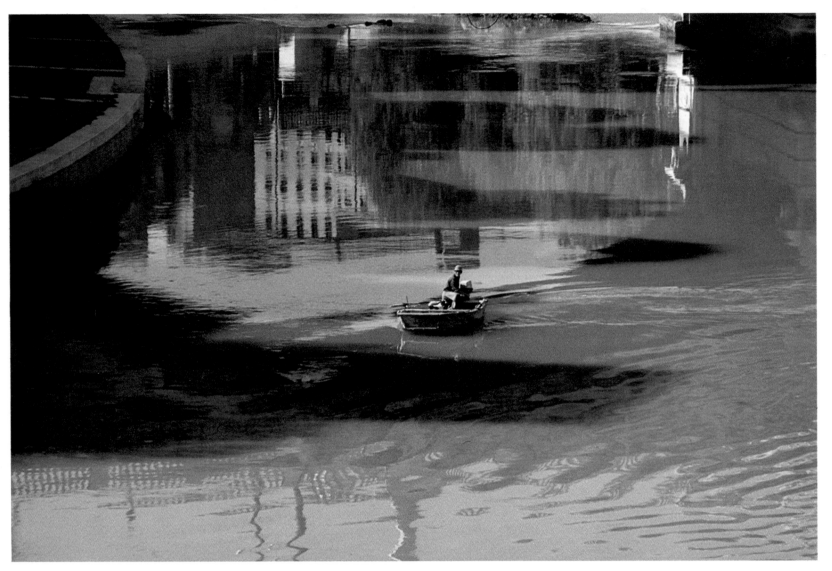

11

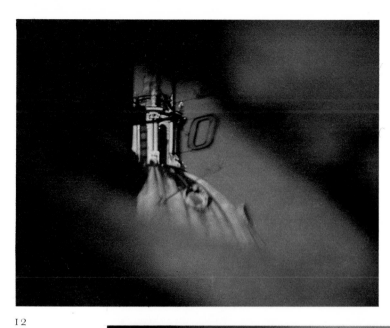

12

13

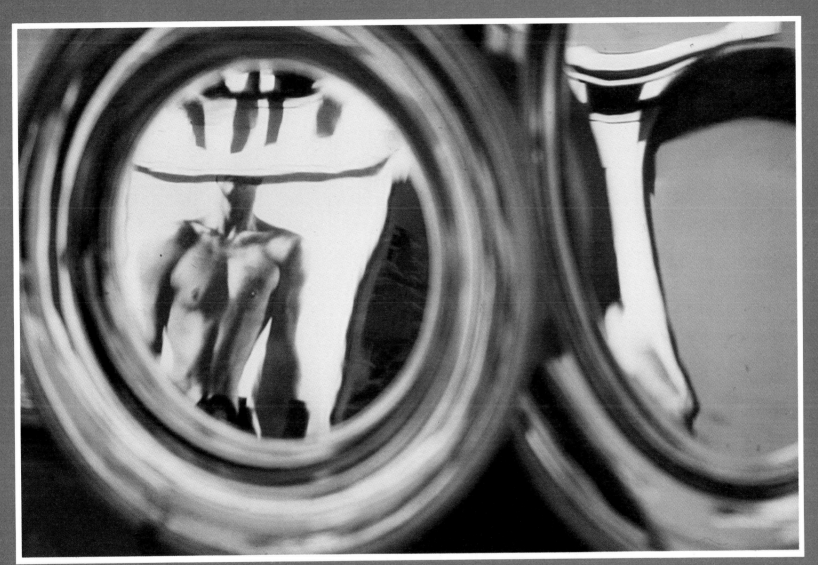

14

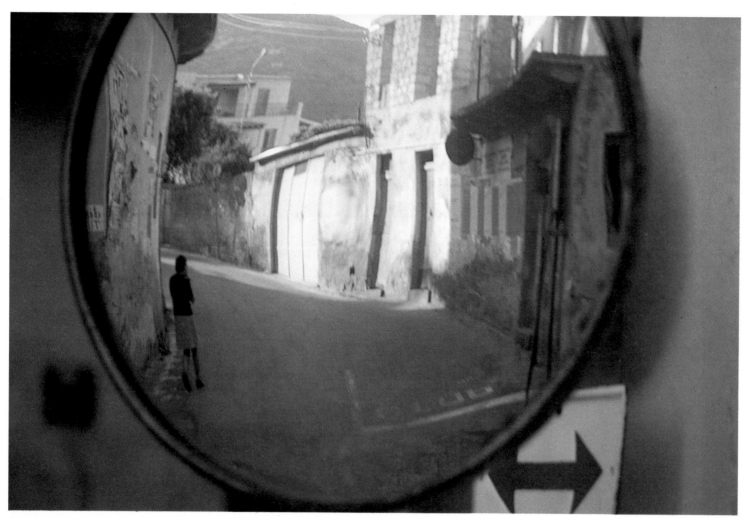

15

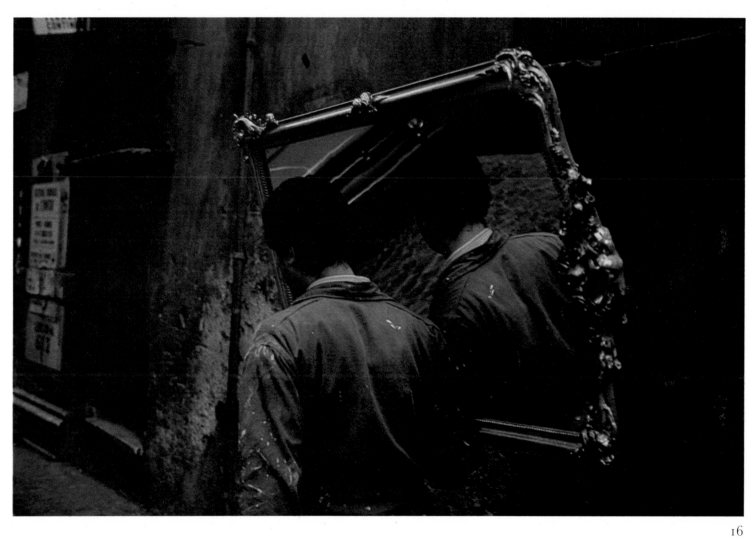

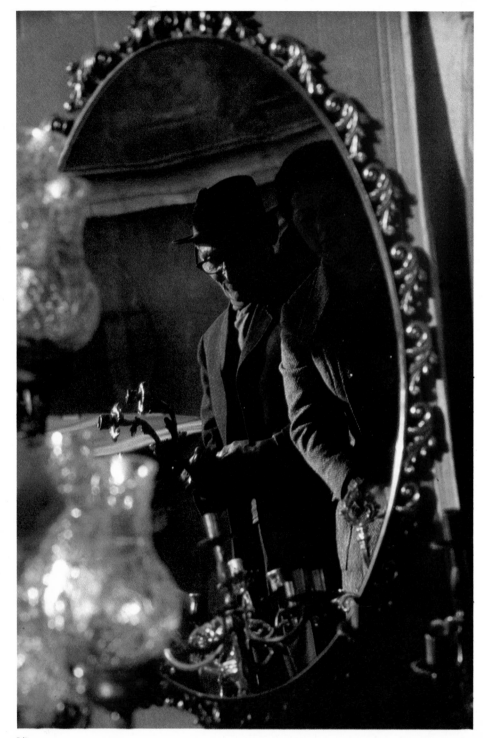

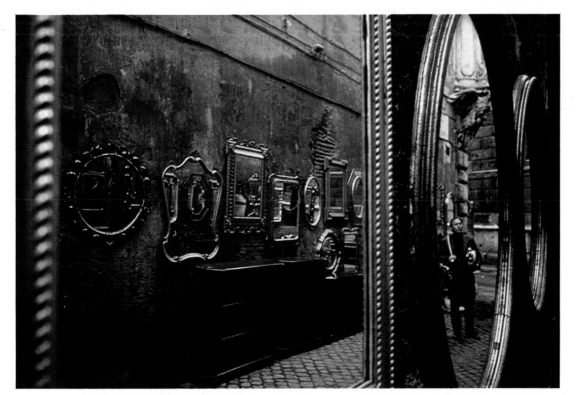

18

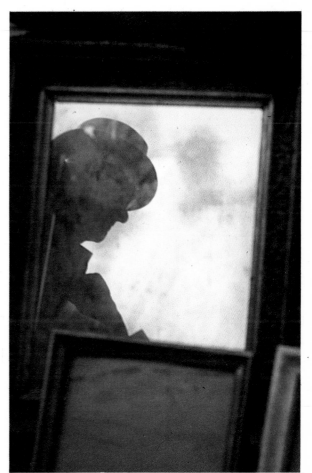

19

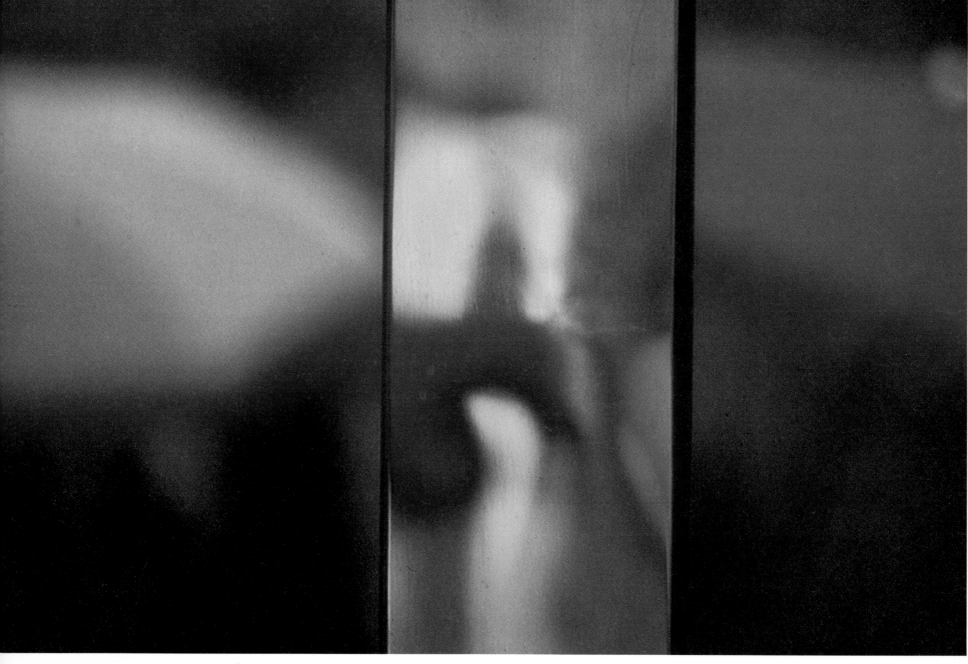

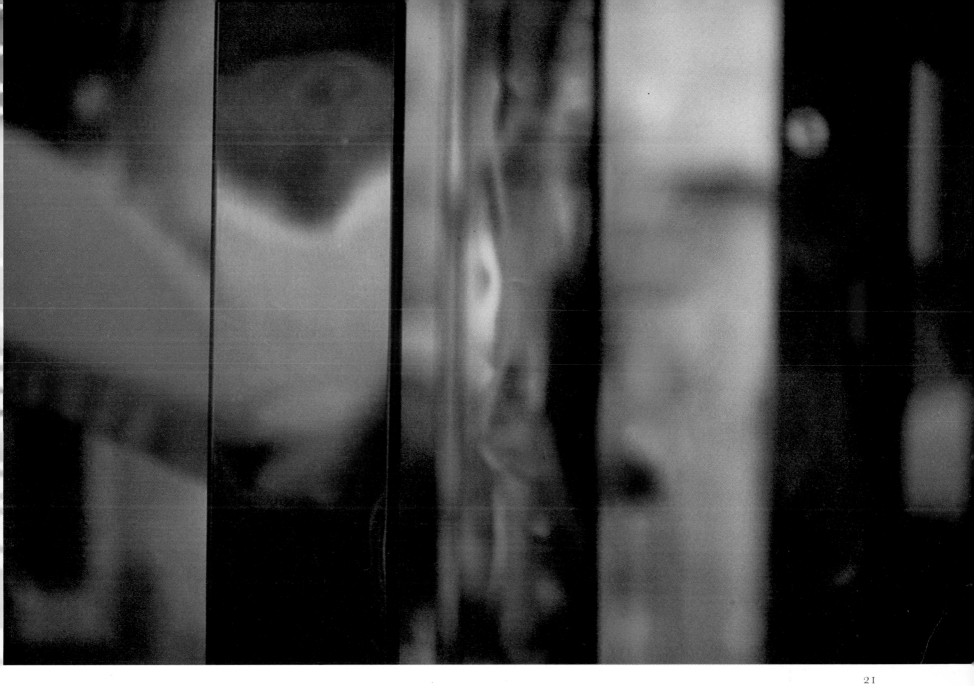

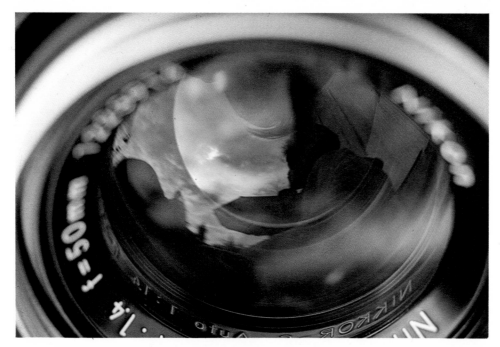

22

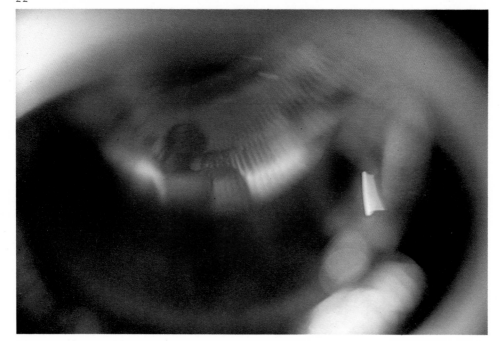

23

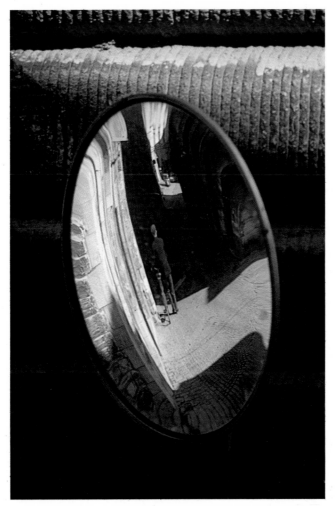

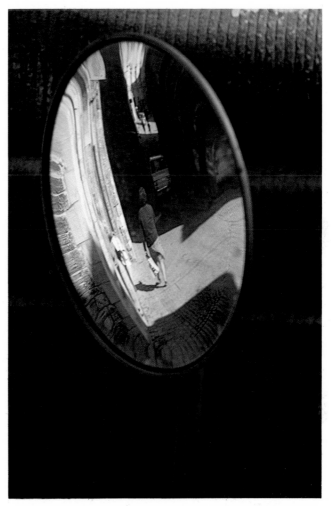

24

25

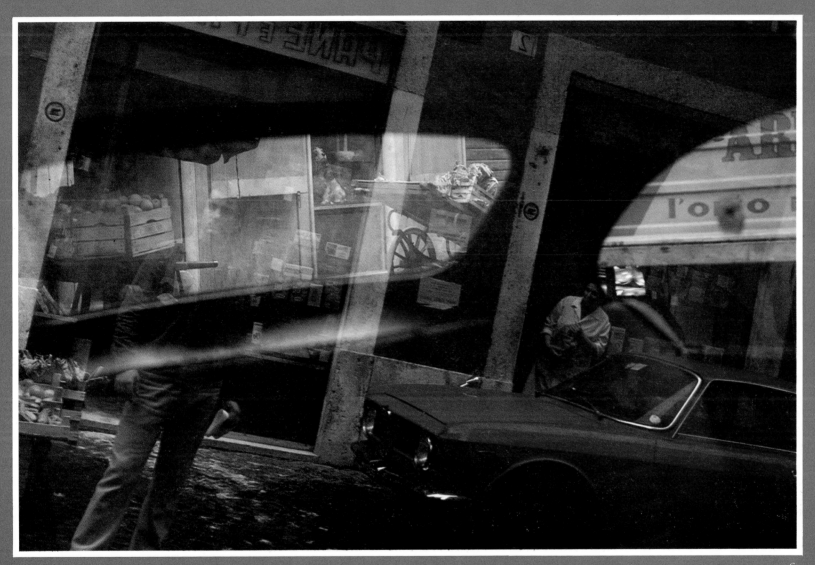

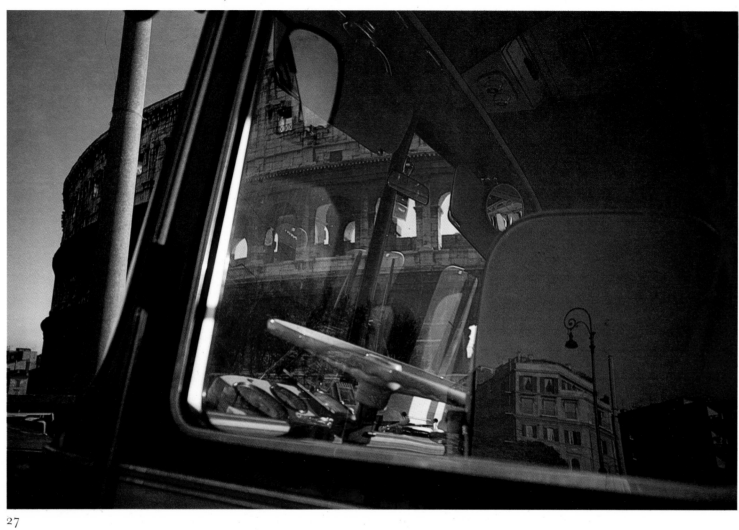

27

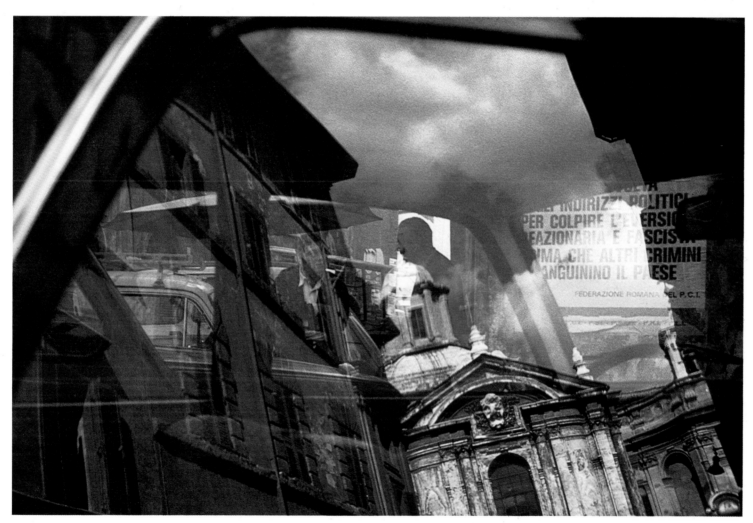

28

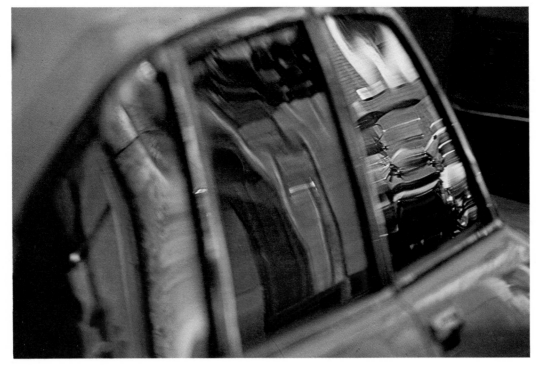

29

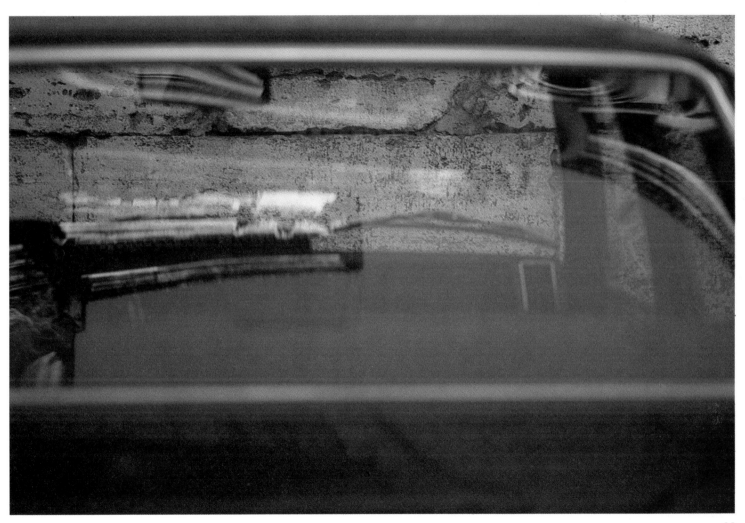

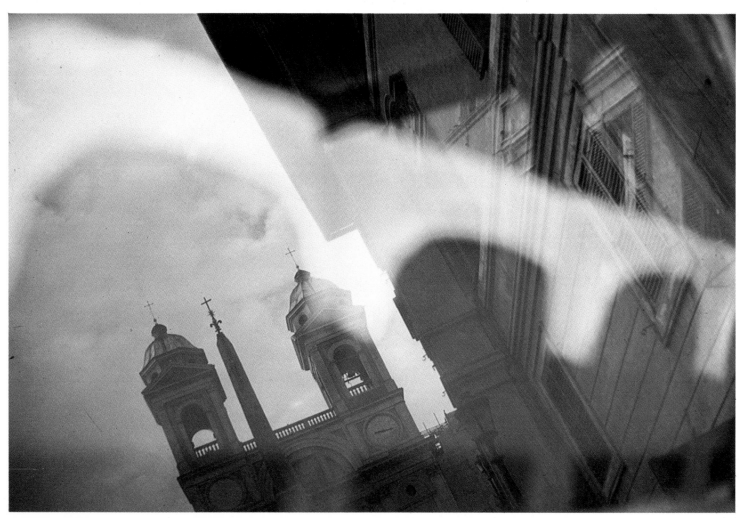

31

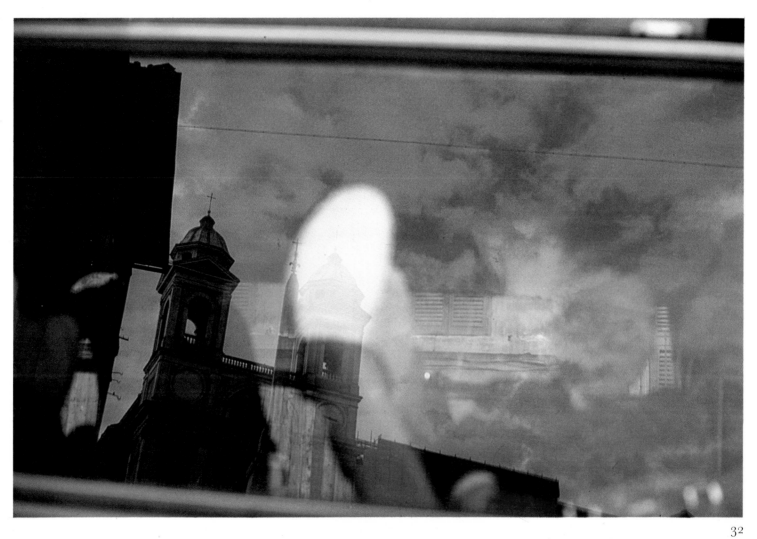

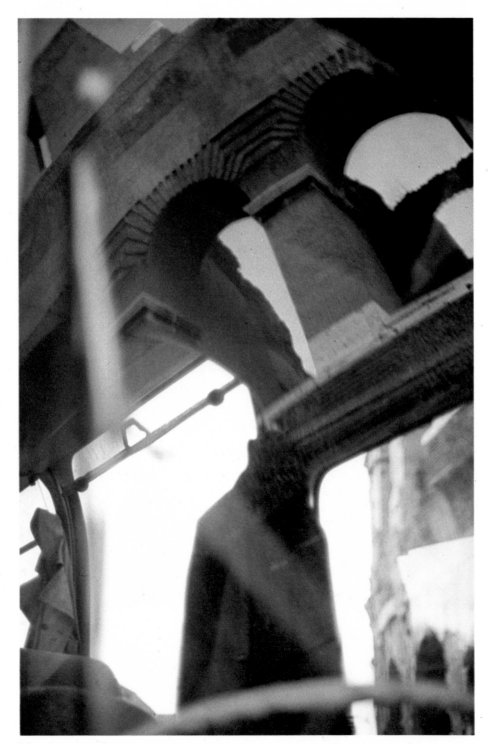

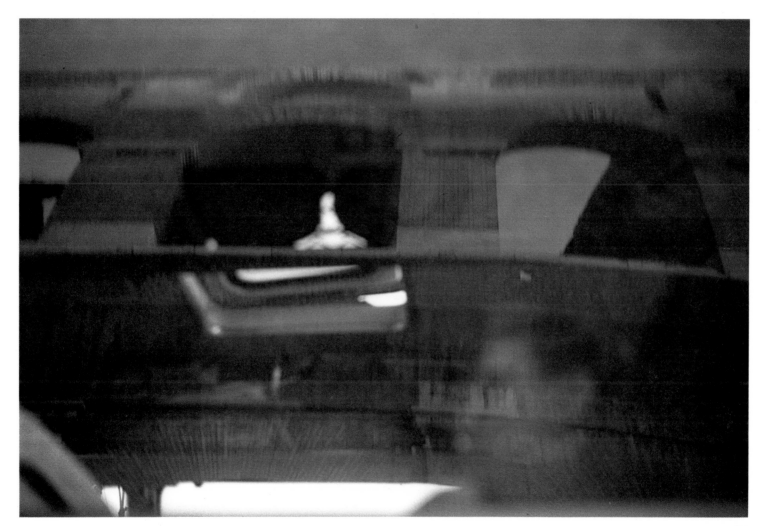

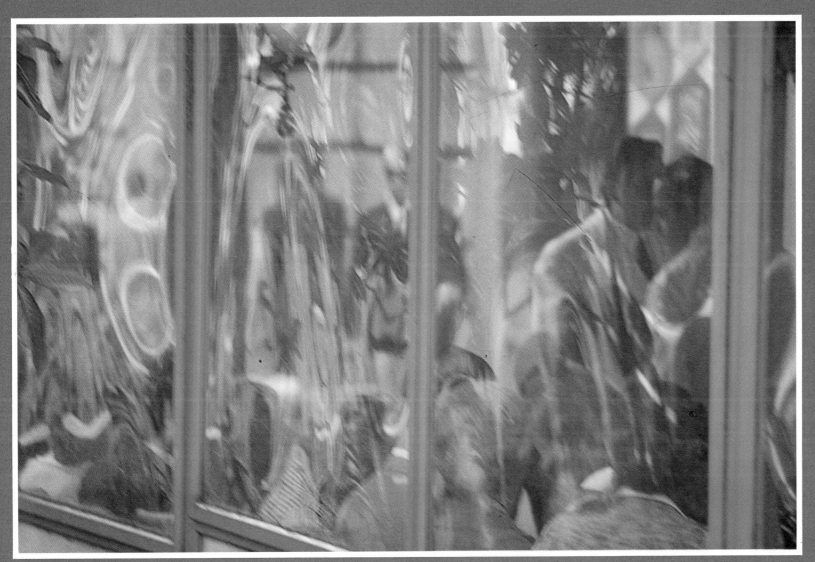

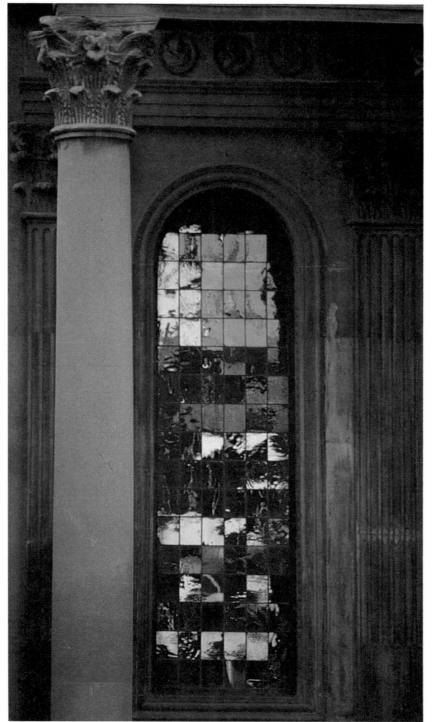

36

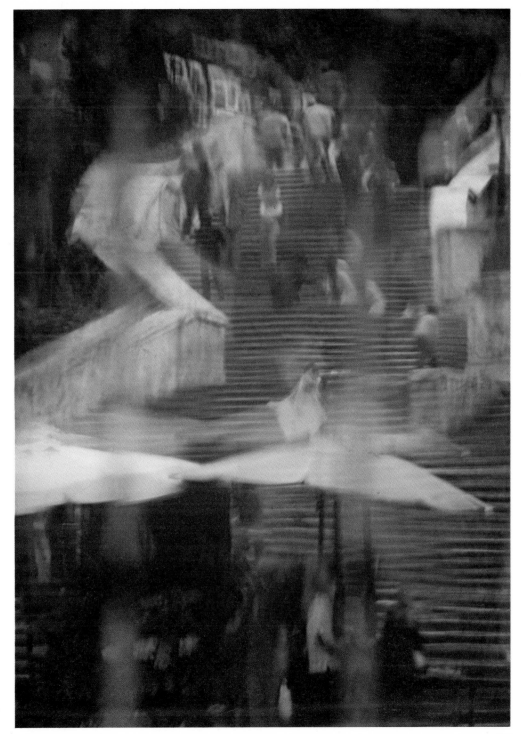

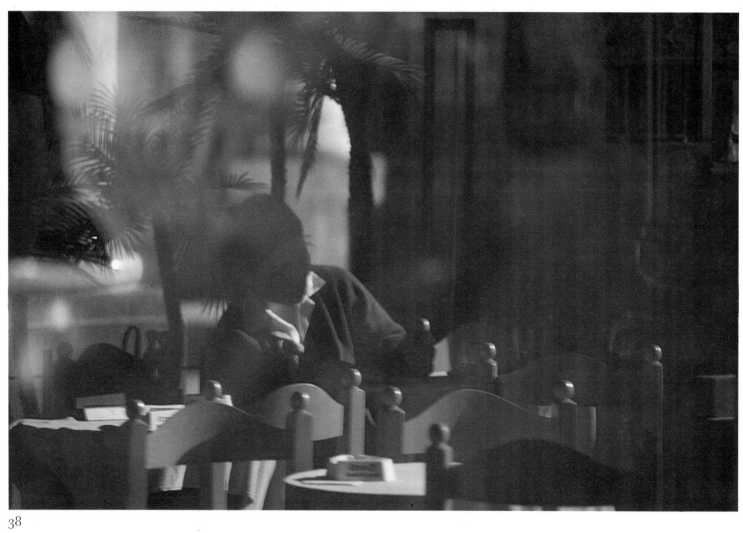

38

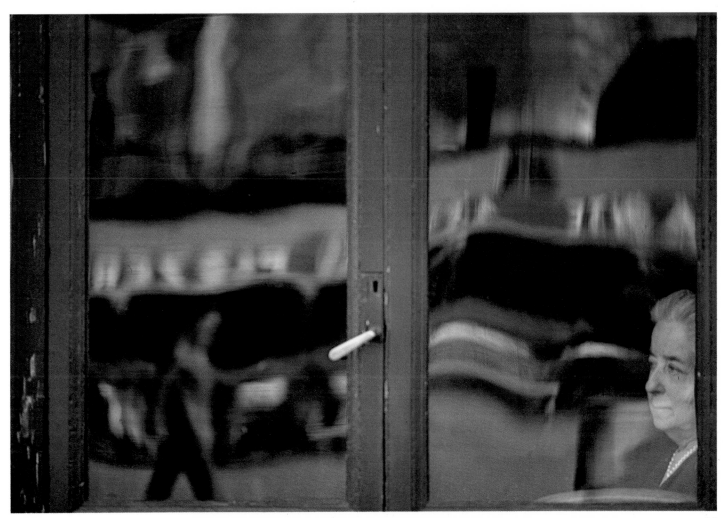

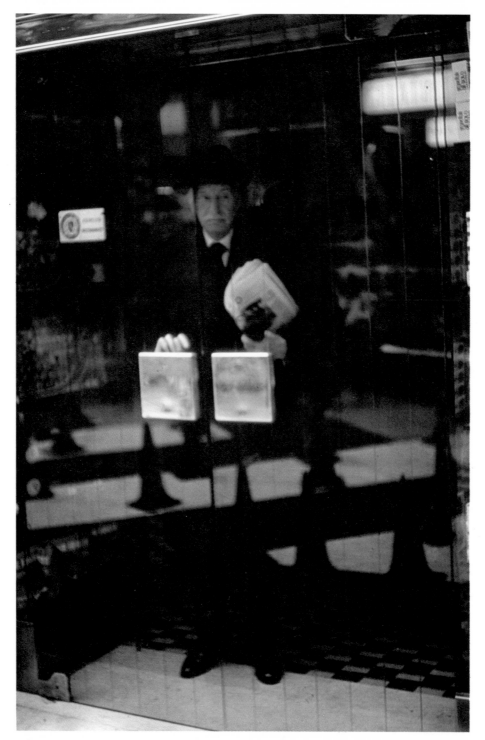

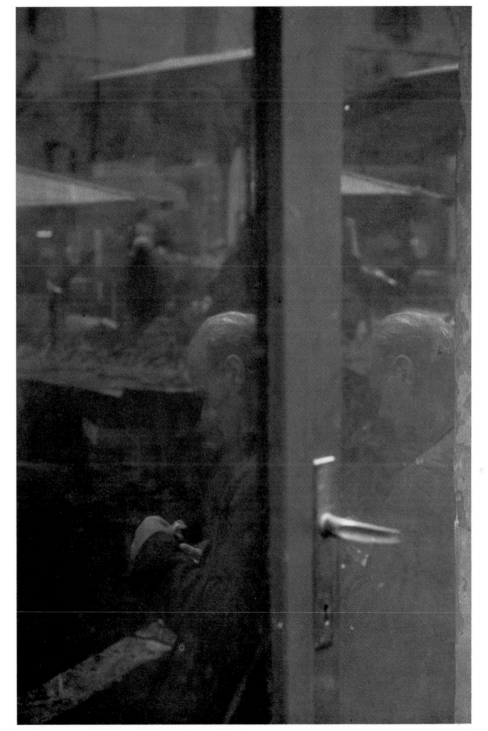

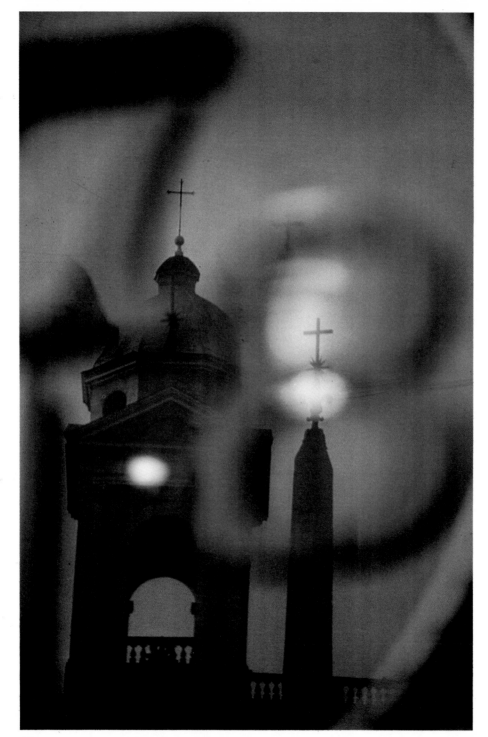

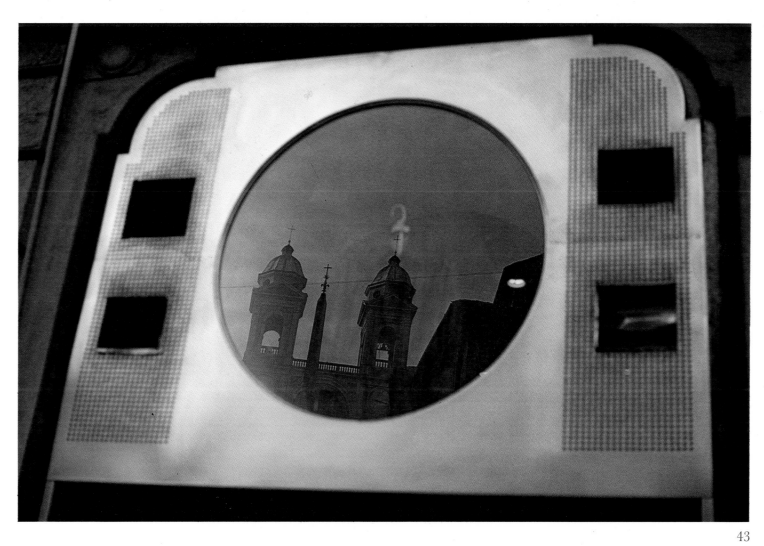

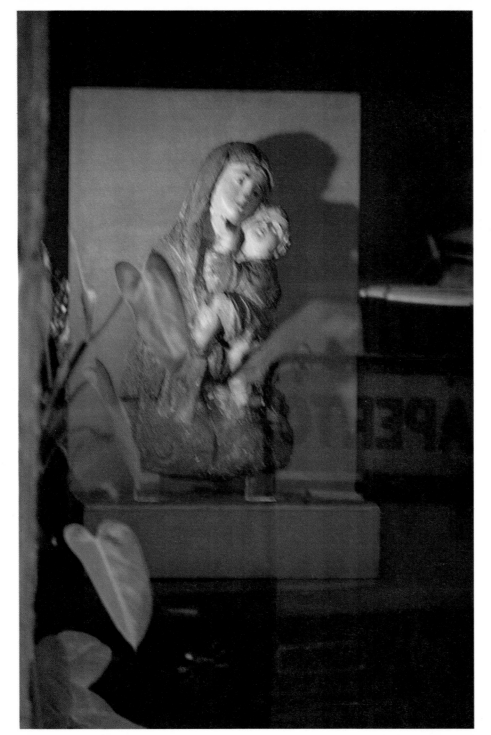

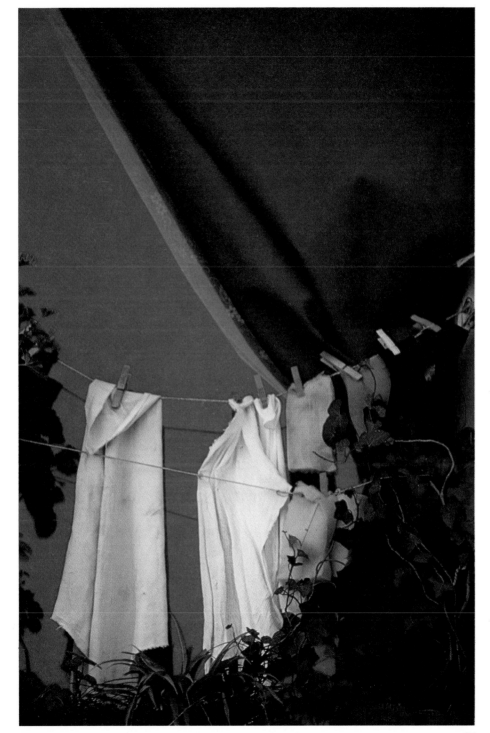

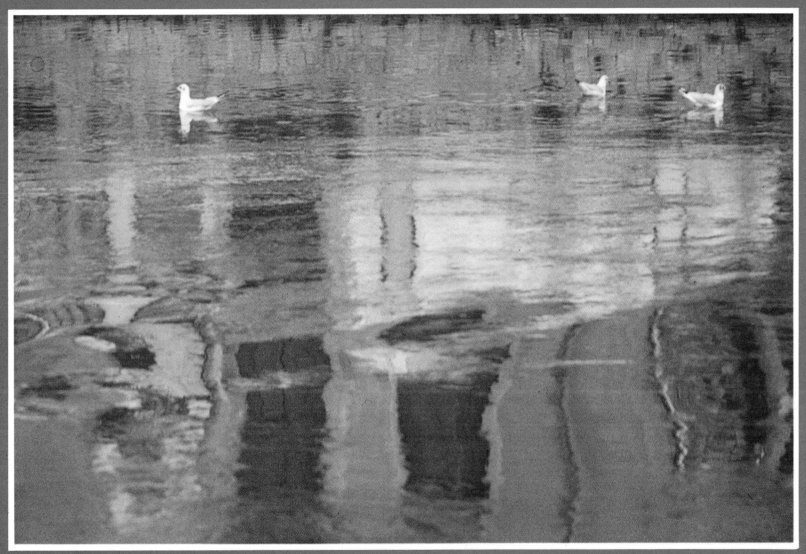

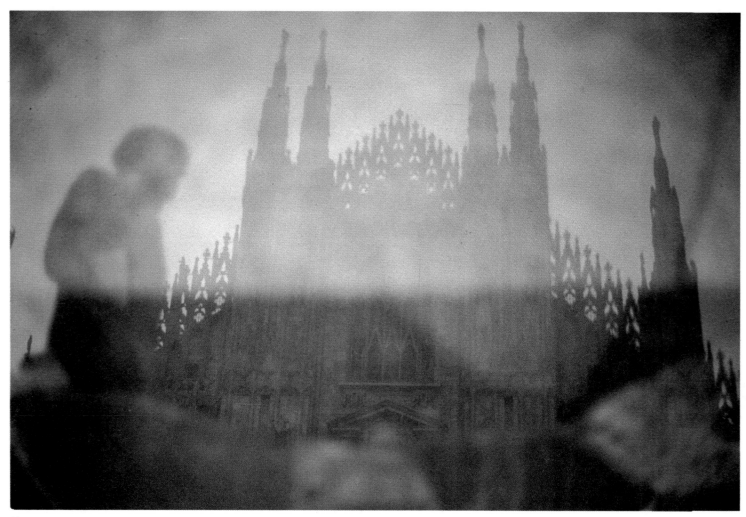

47

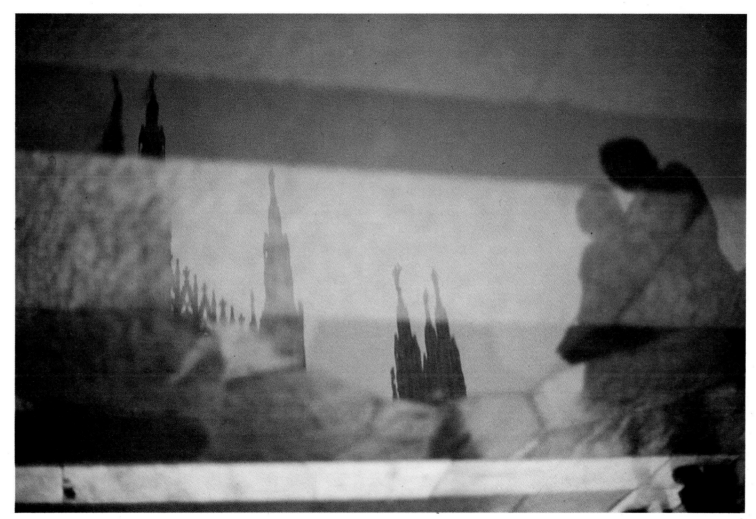

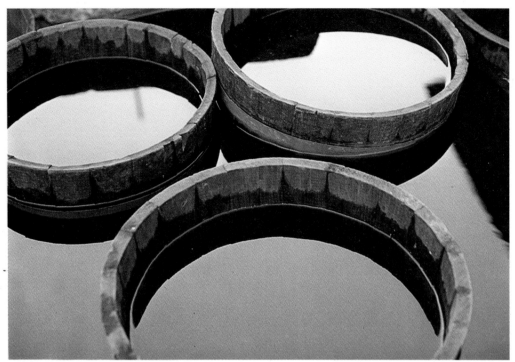

49

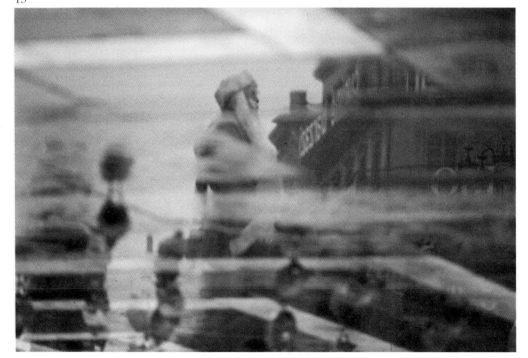

50

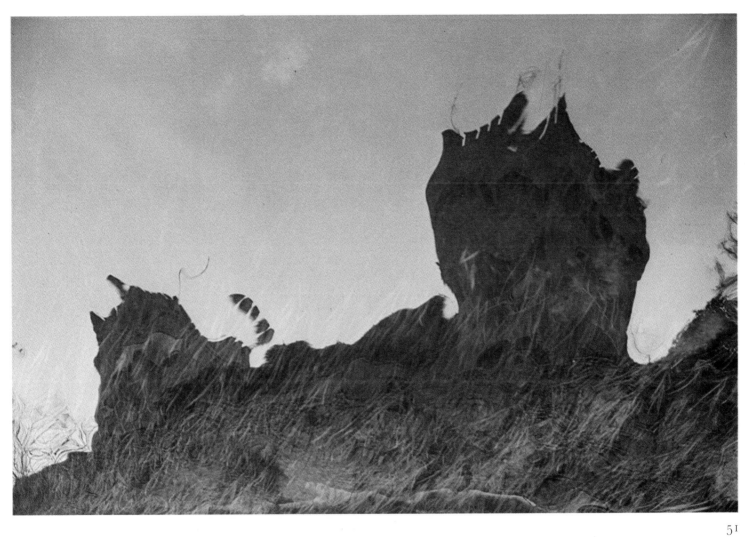

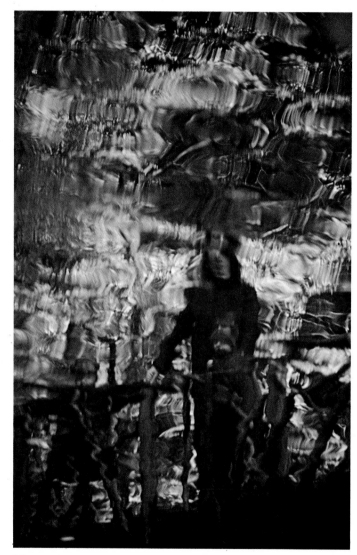

52

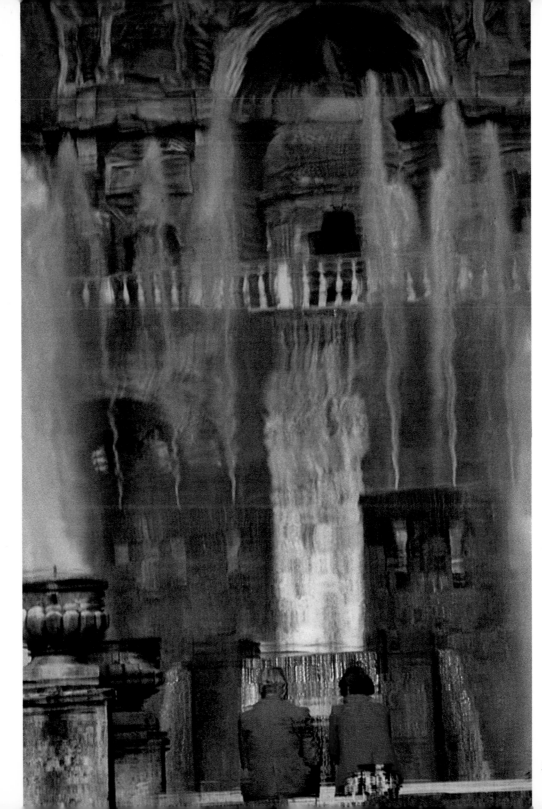

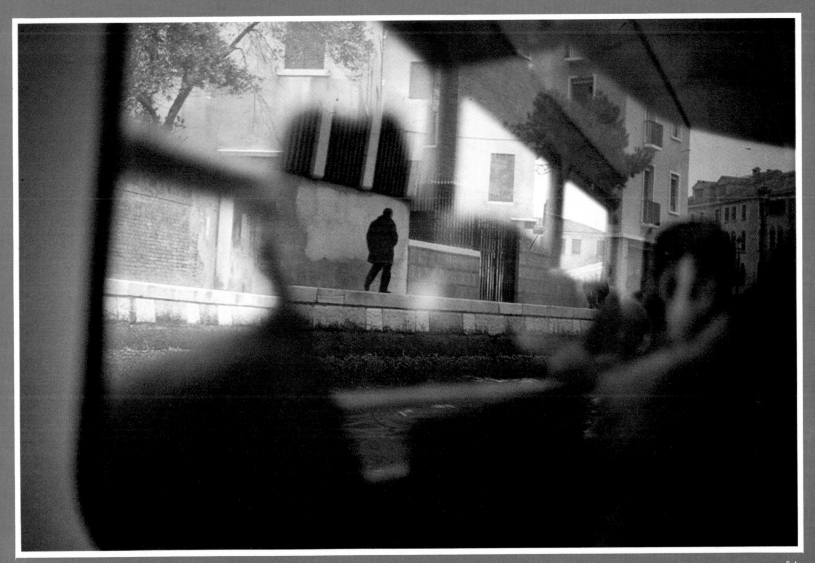

54

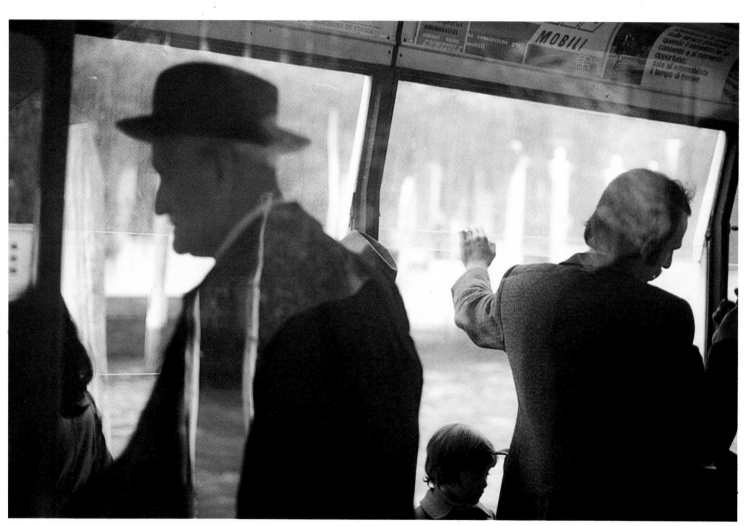

55

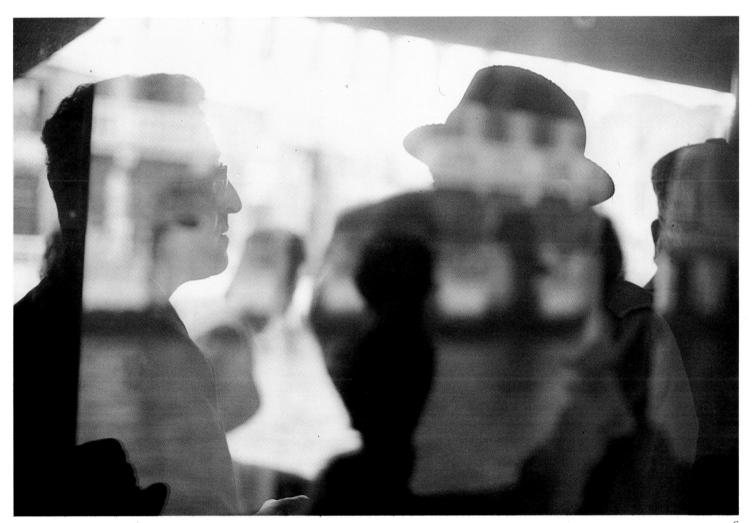

56

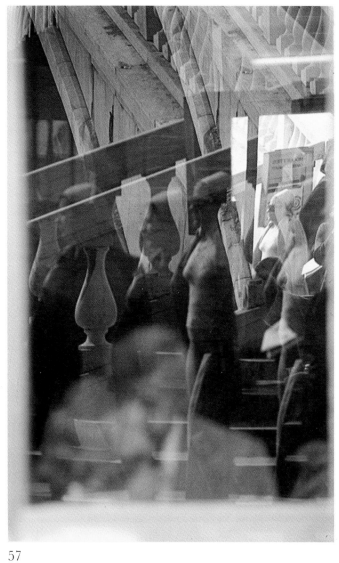

57

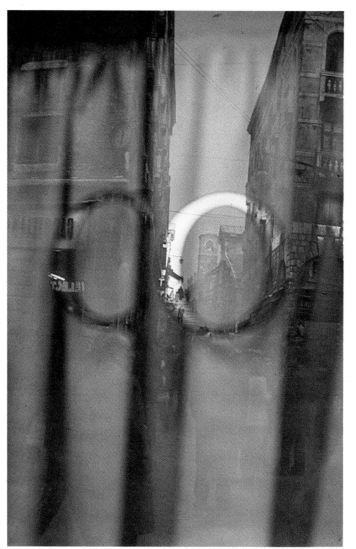

58

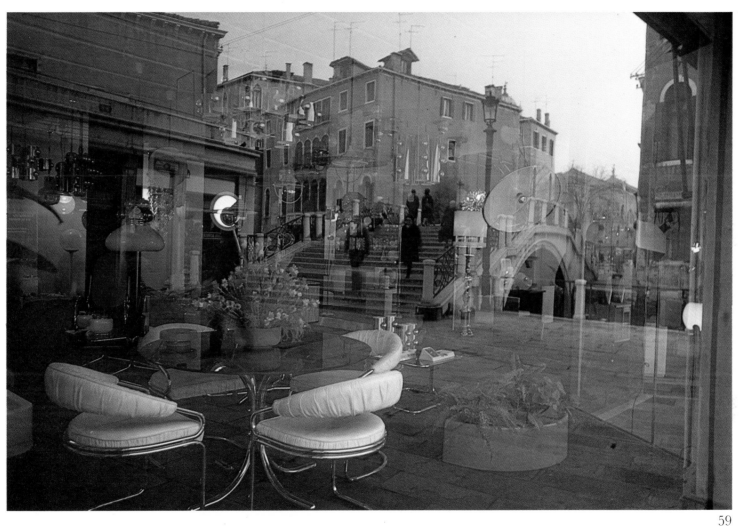

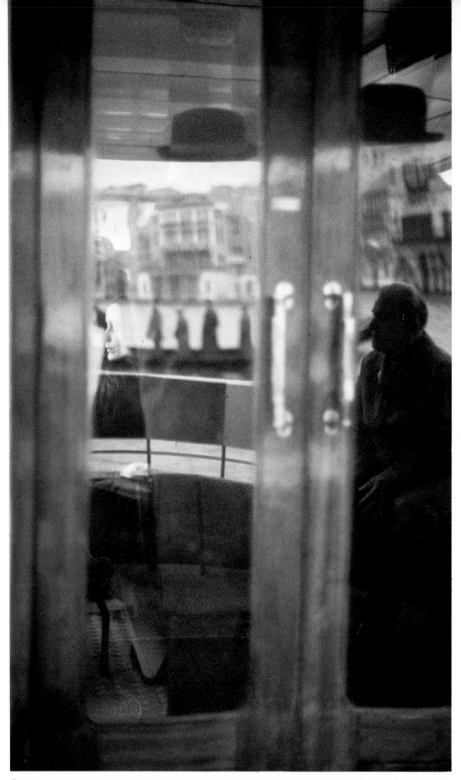

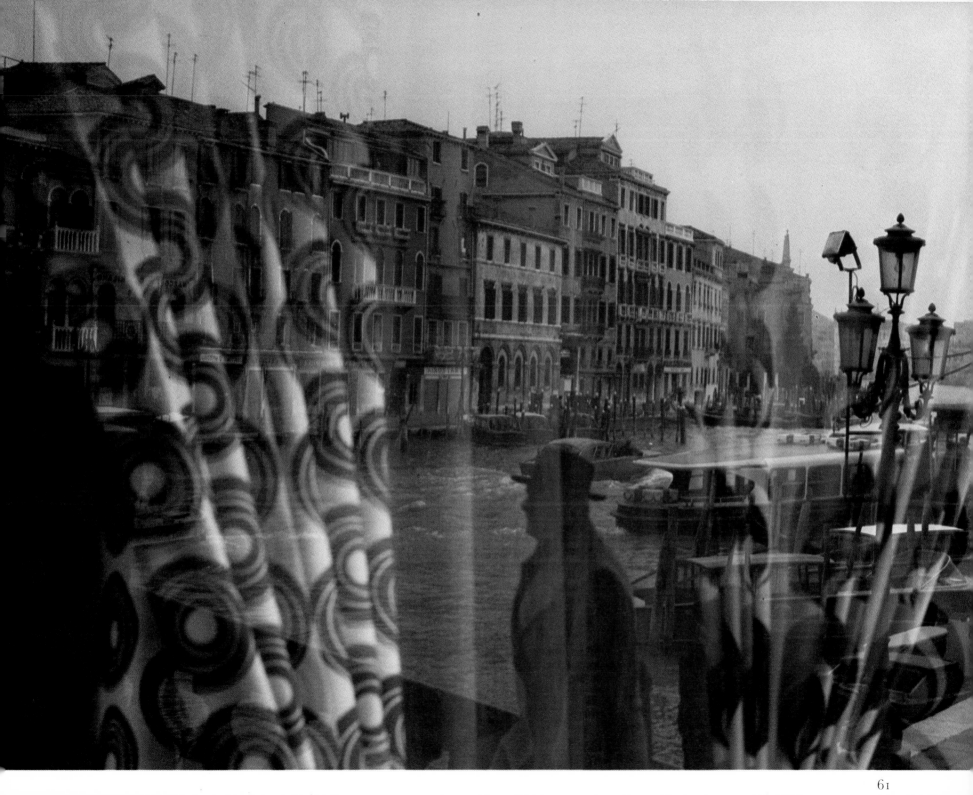

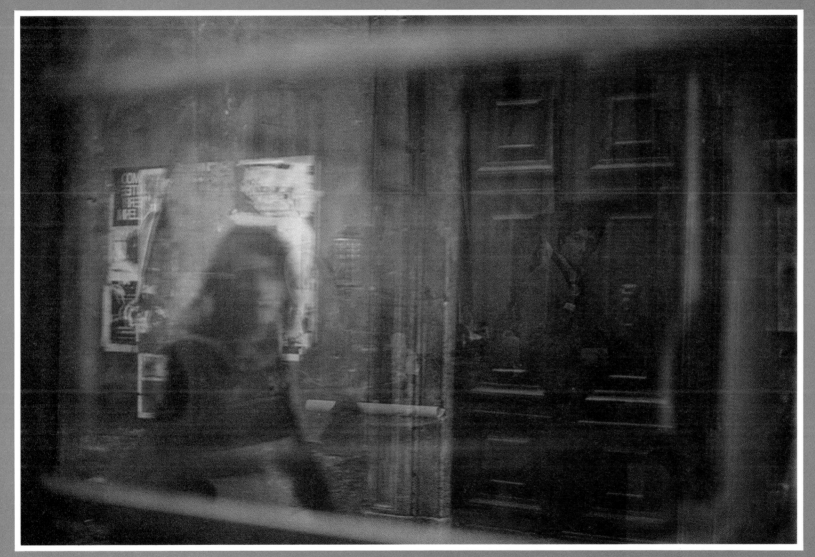

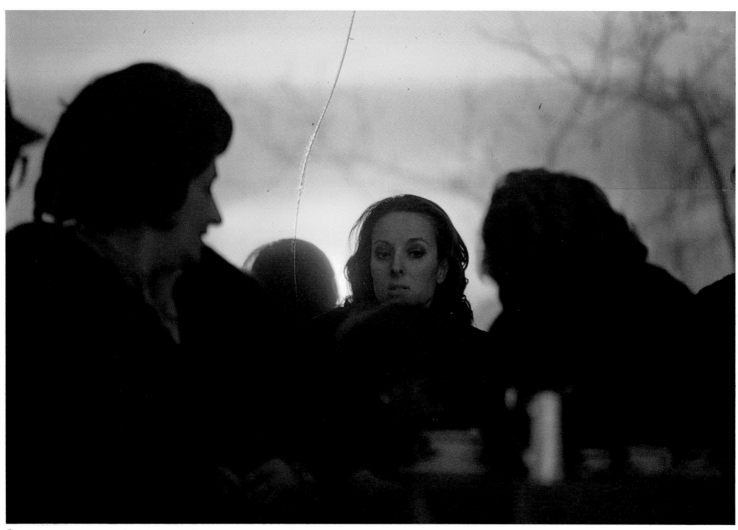

63

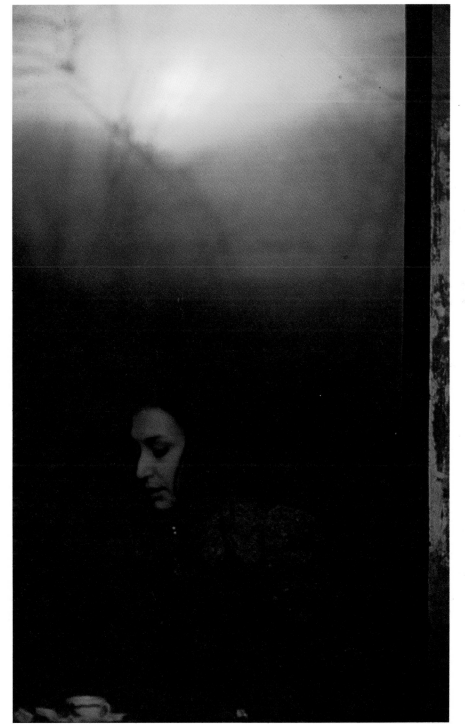

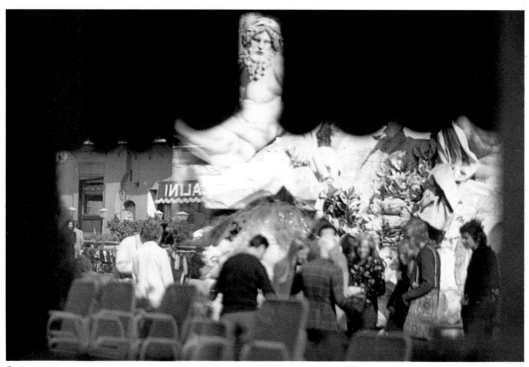

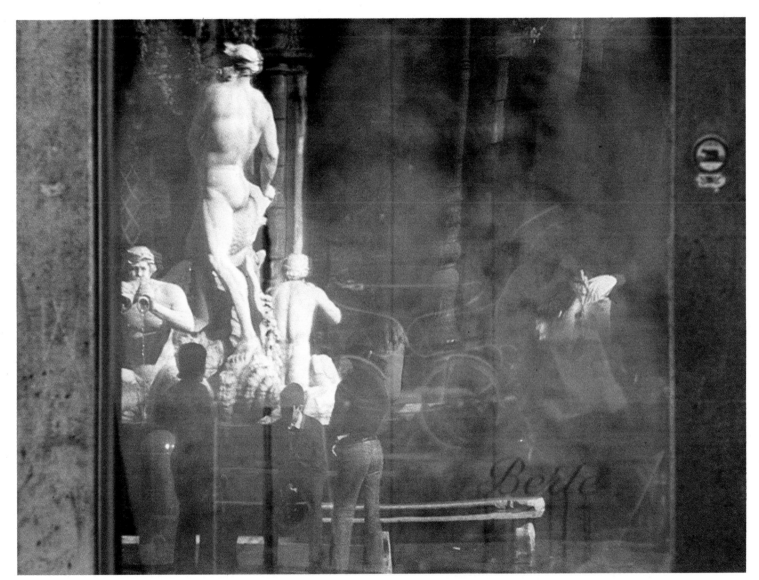

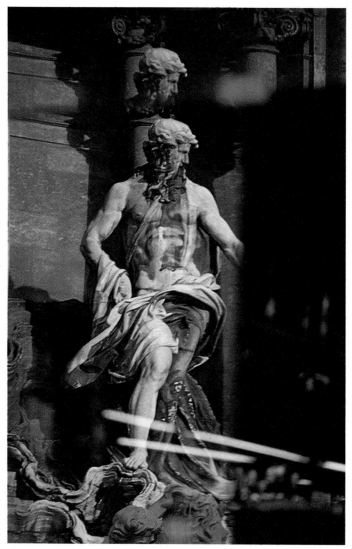

67

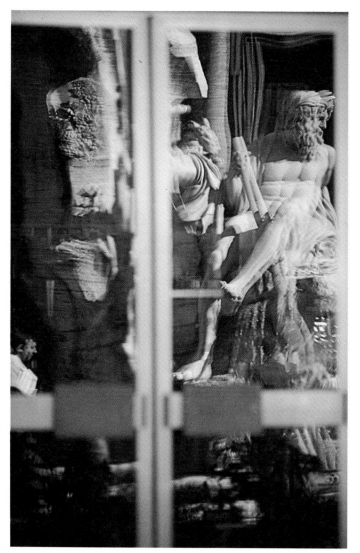

68

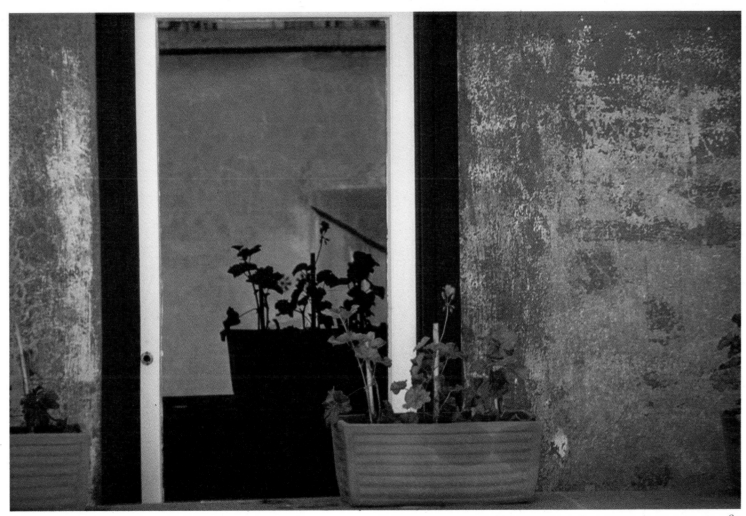

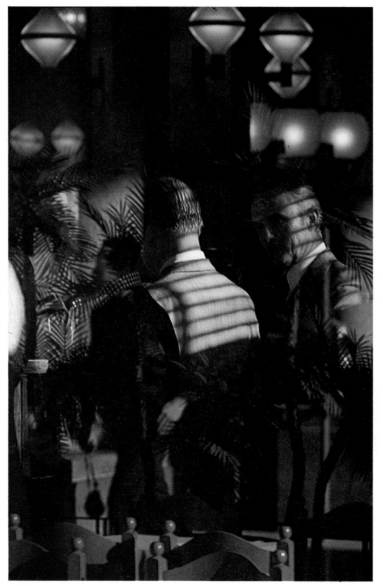

70

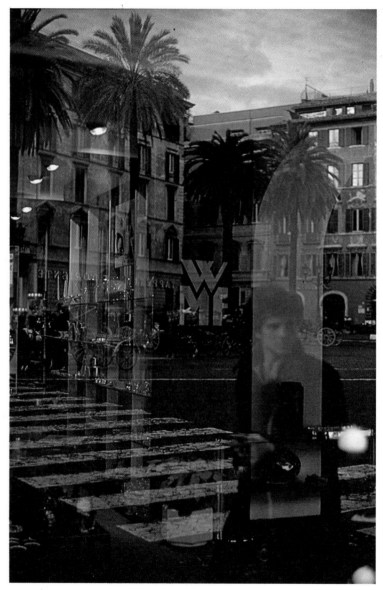

71

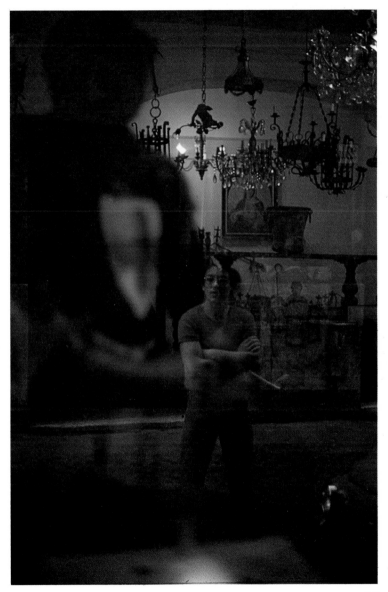

72

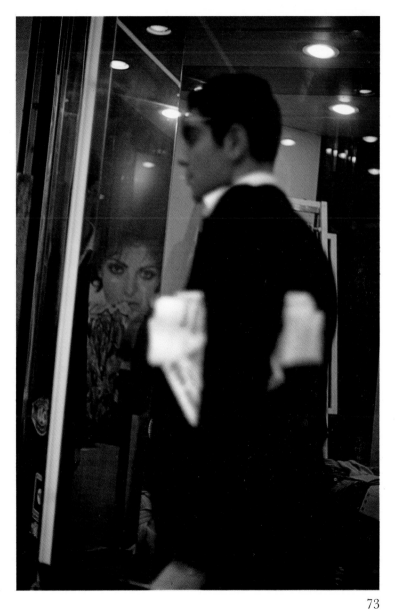

73

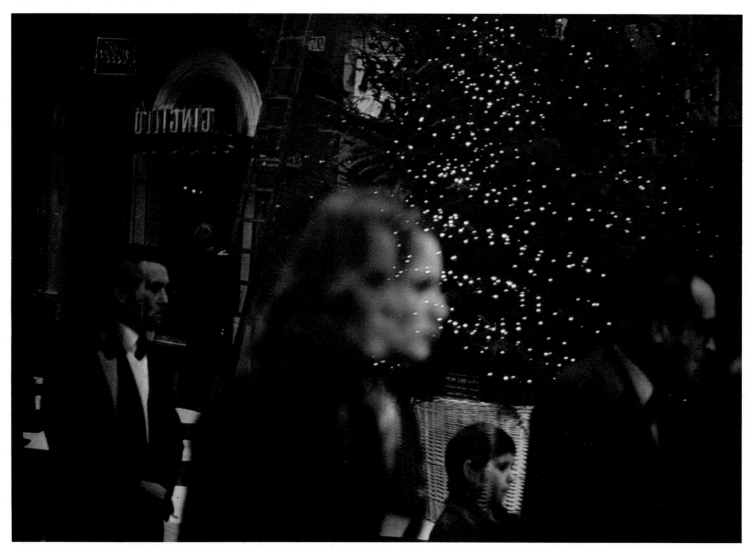

74

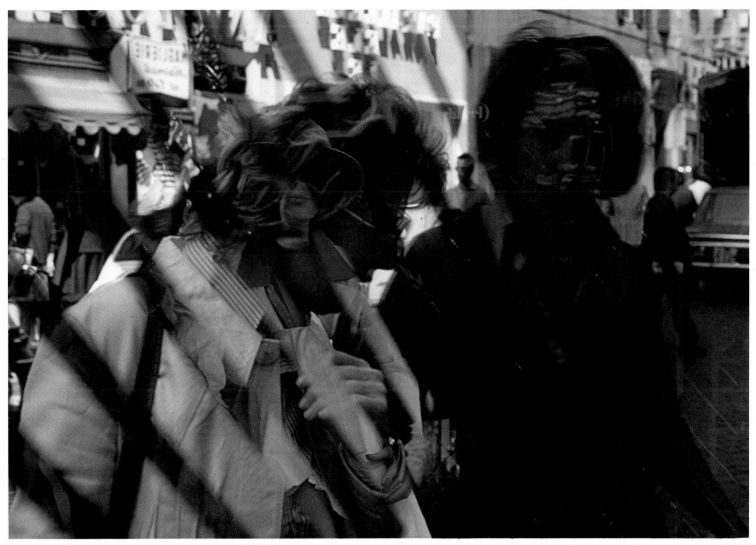

75

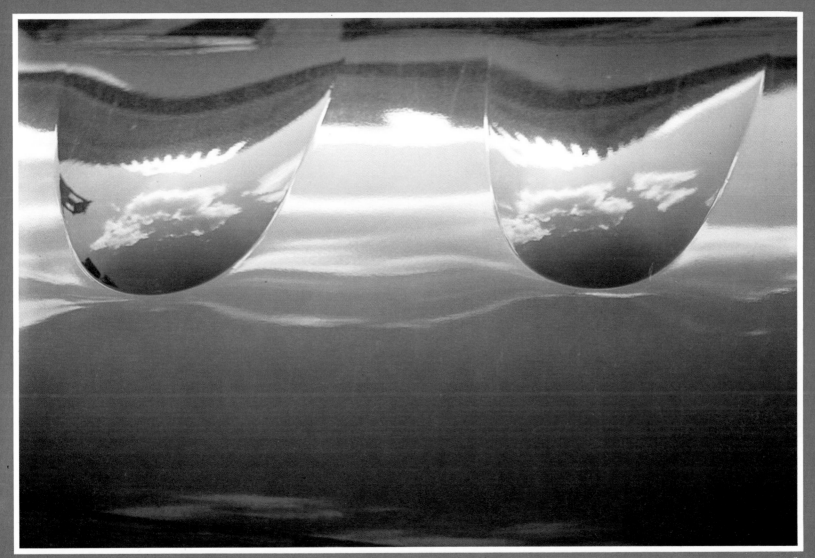

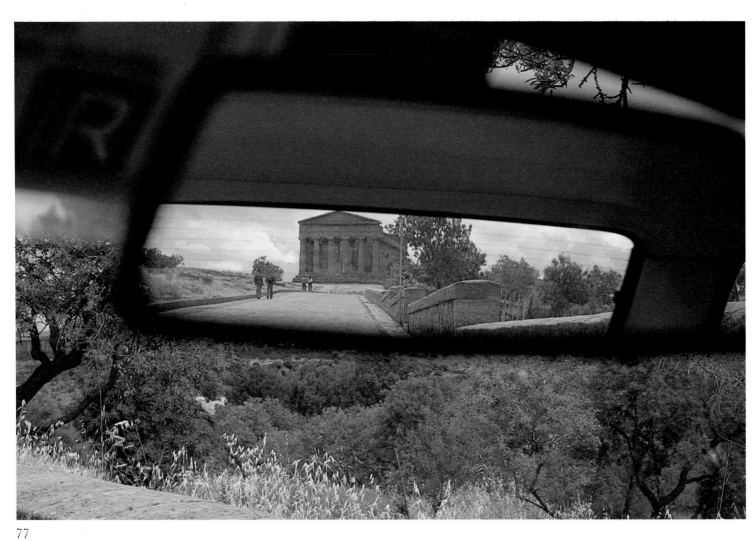

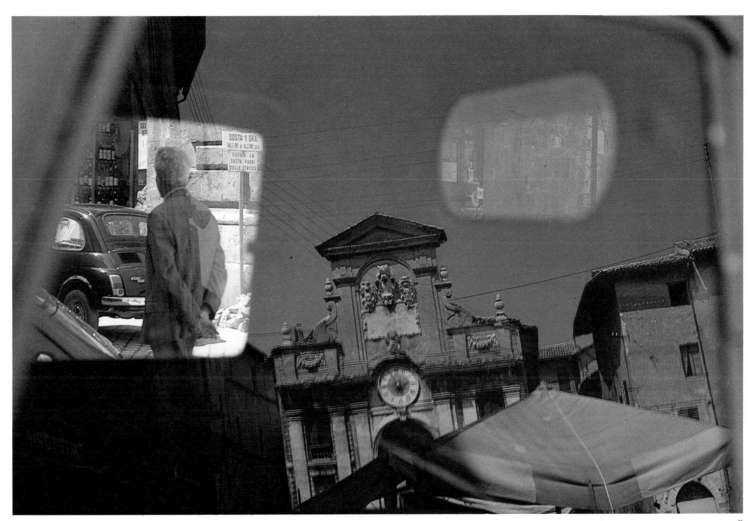

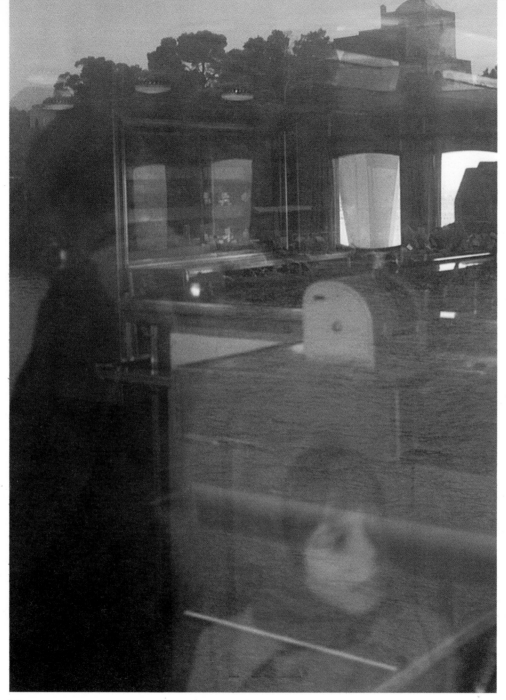

79

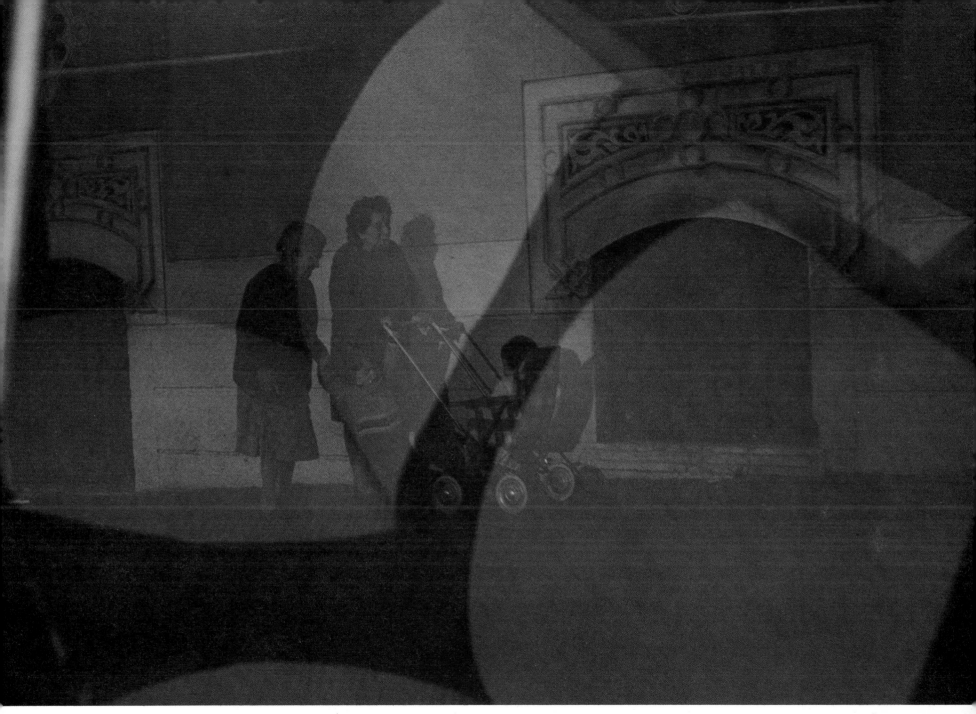

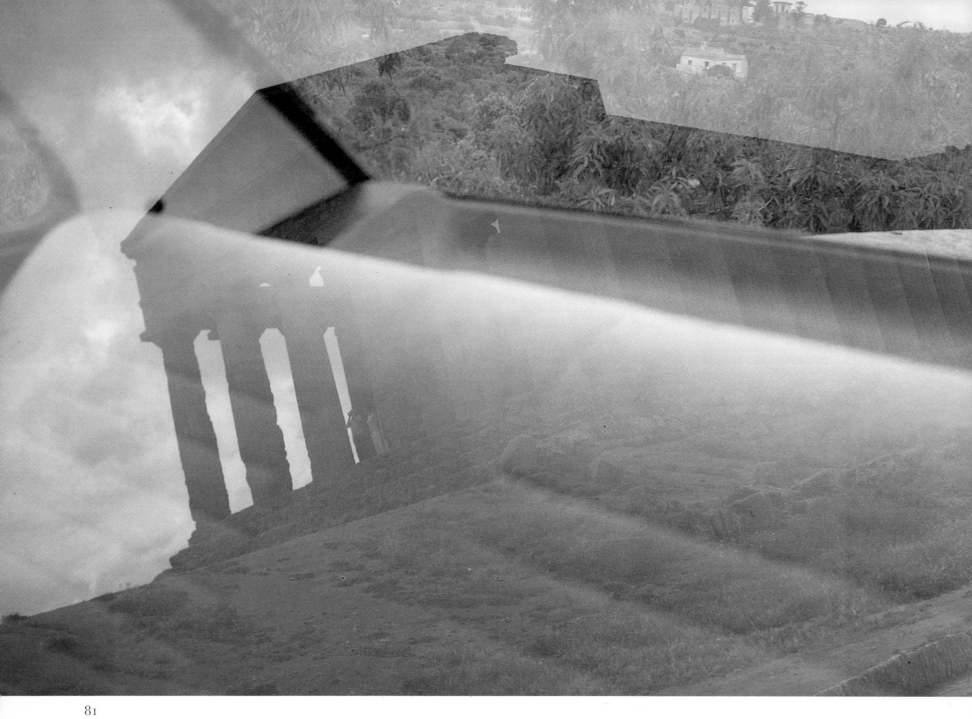

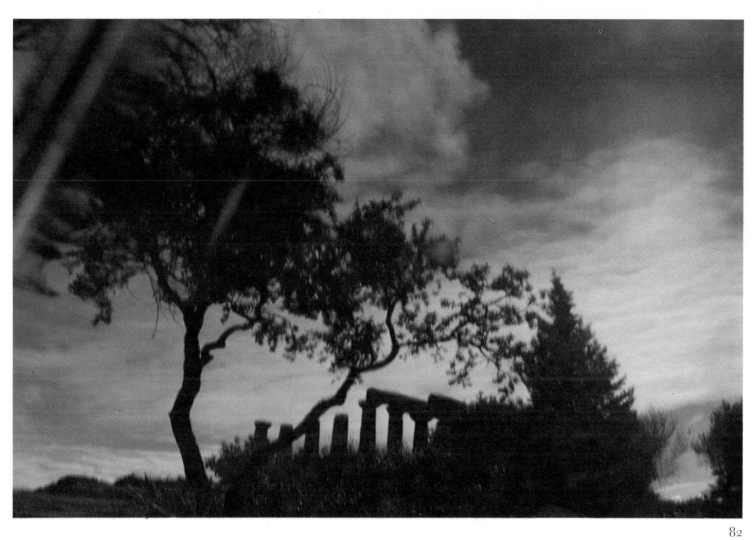

82

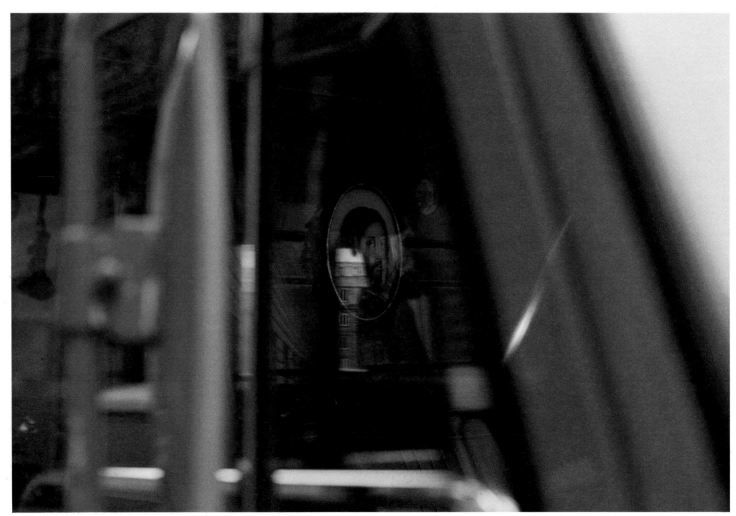

83

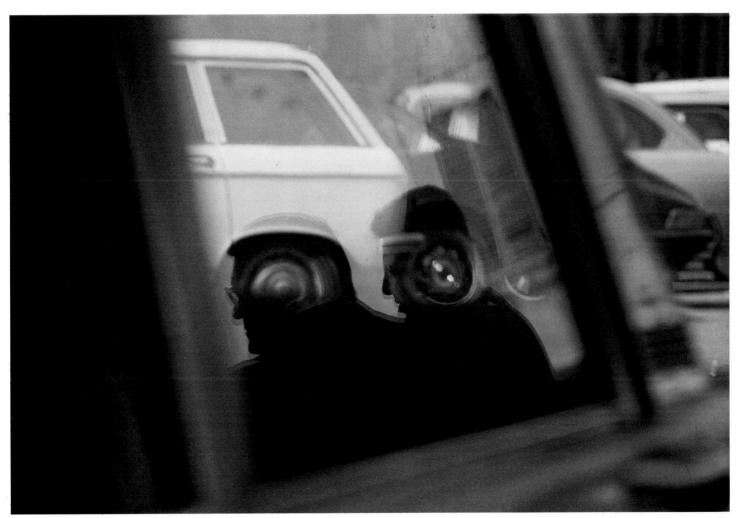

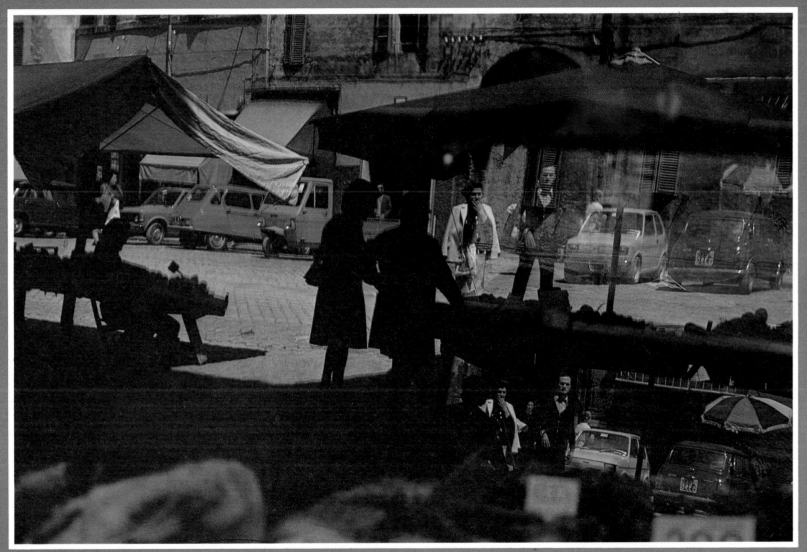

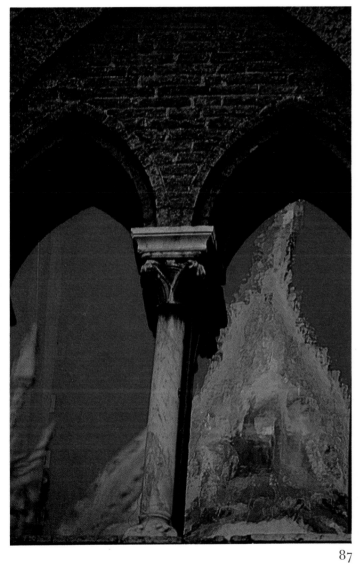

87

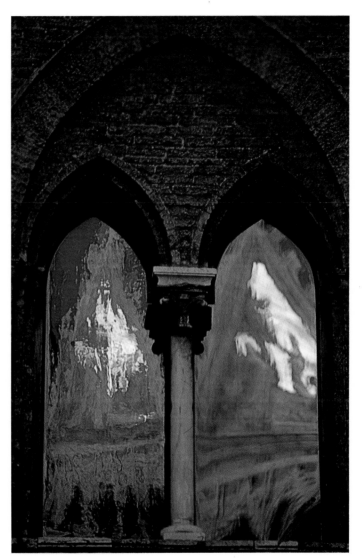

88

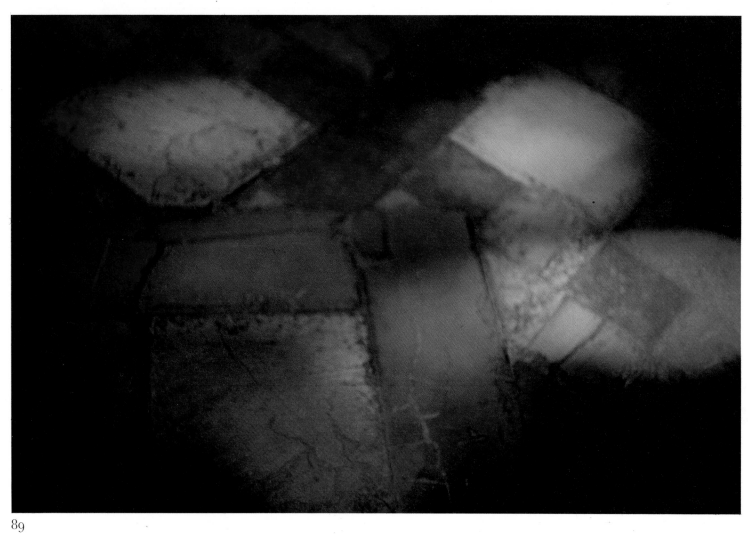

89

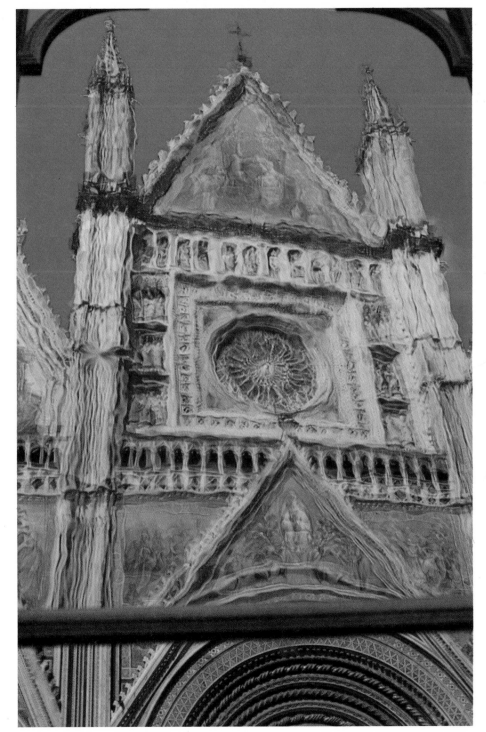

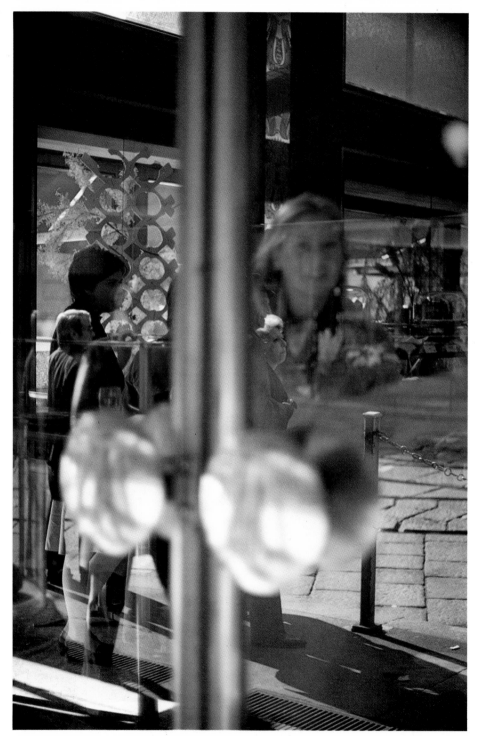

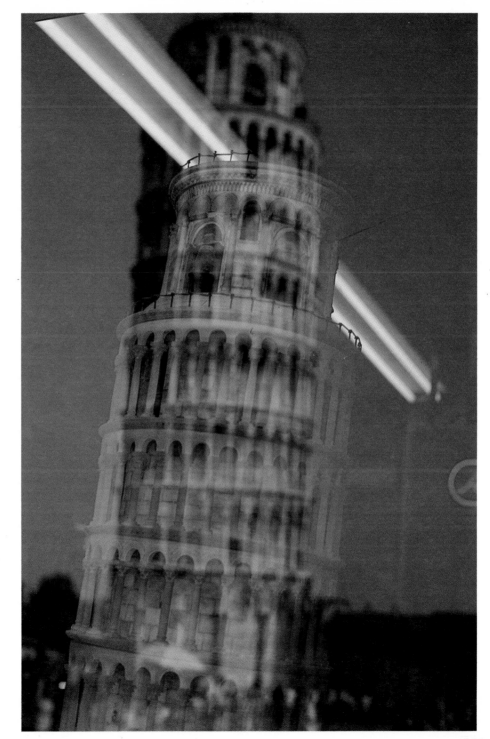

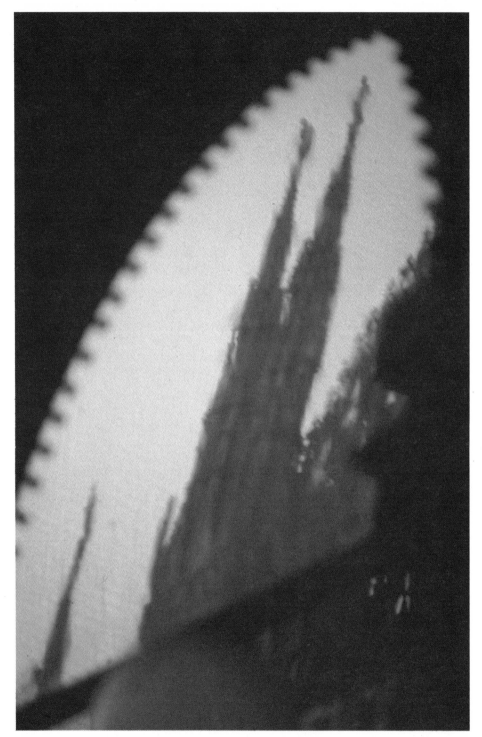

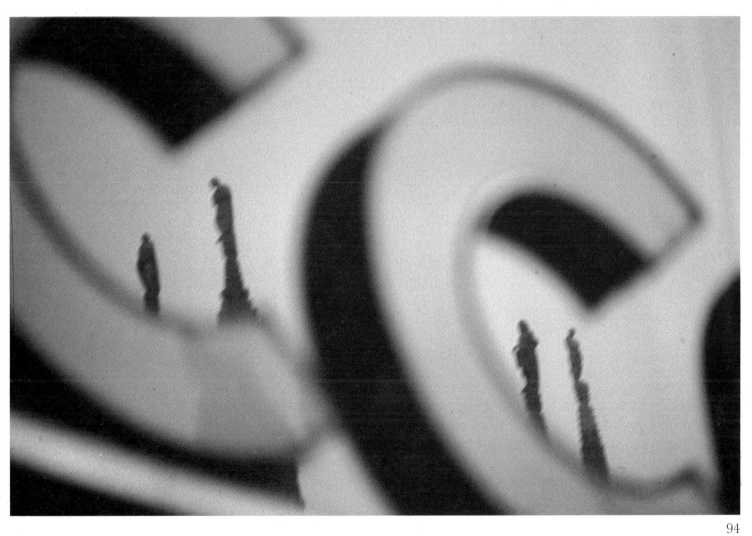

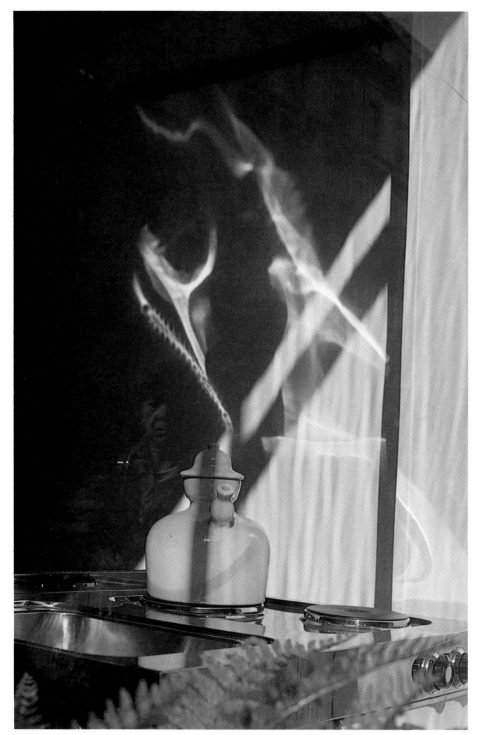

95

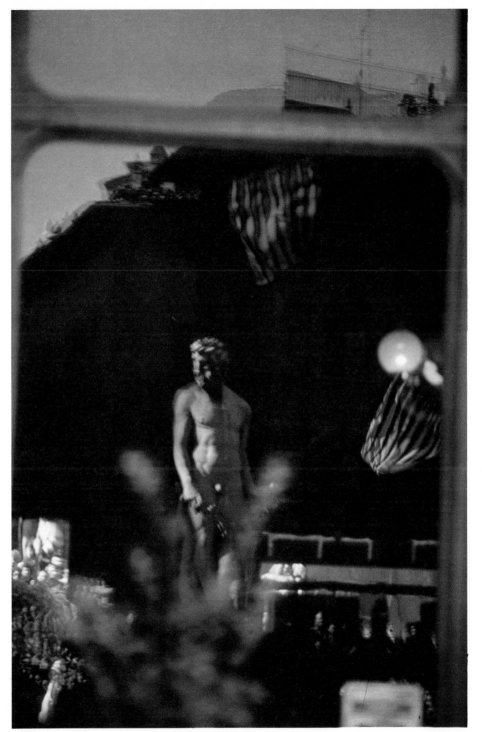

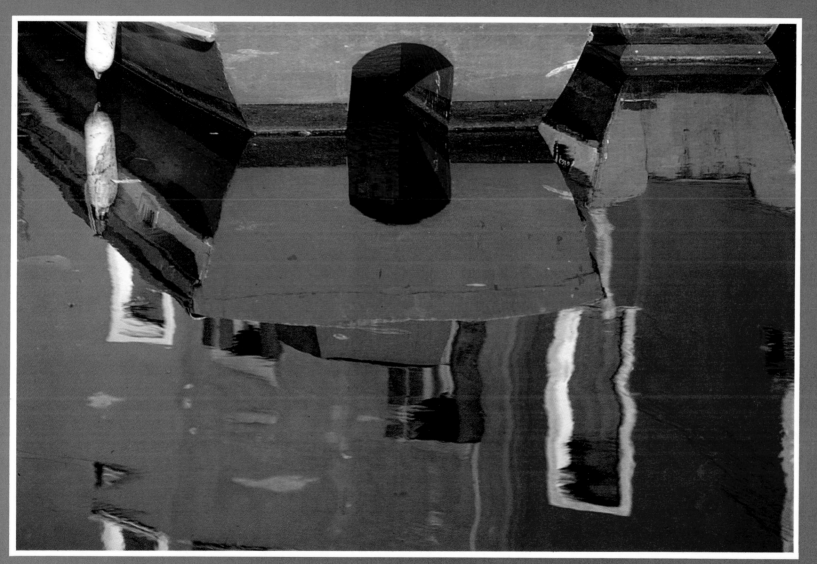

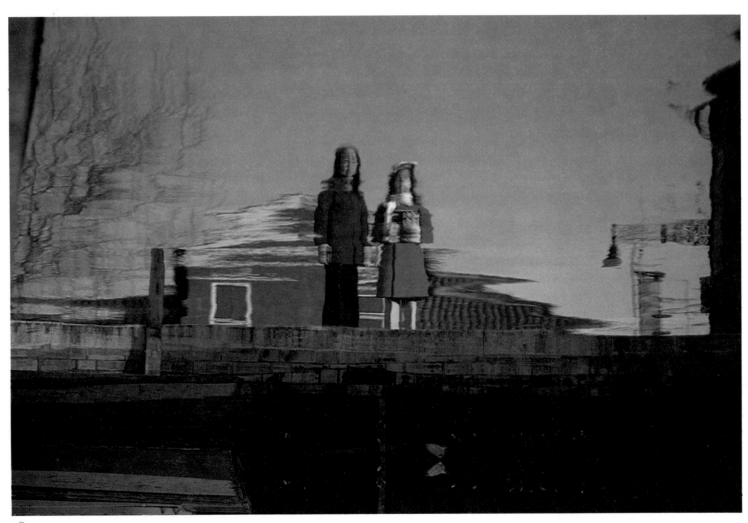

98

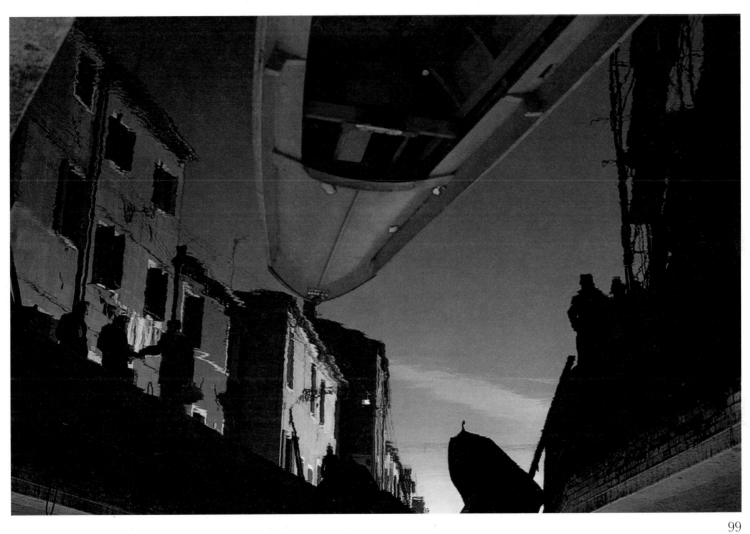

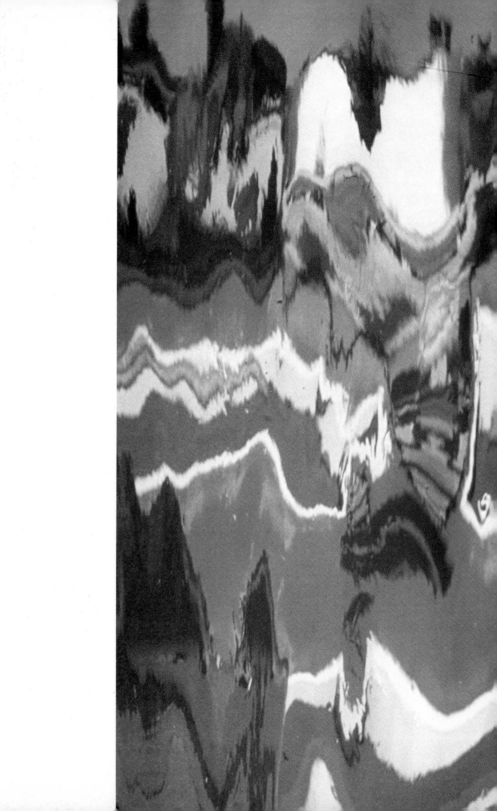

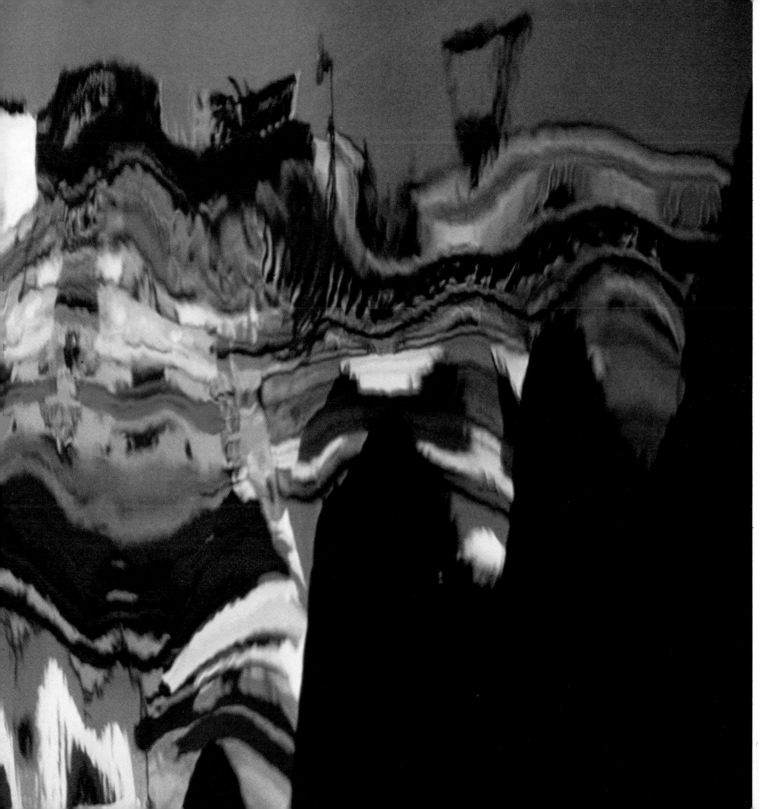

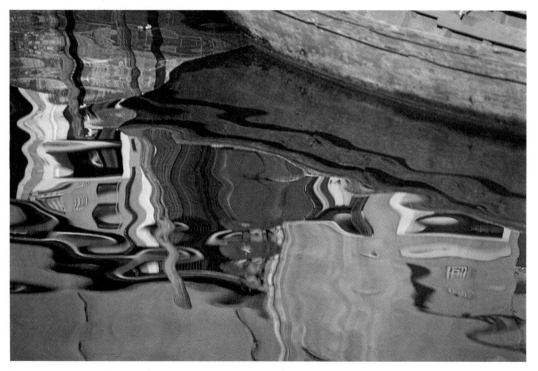

101

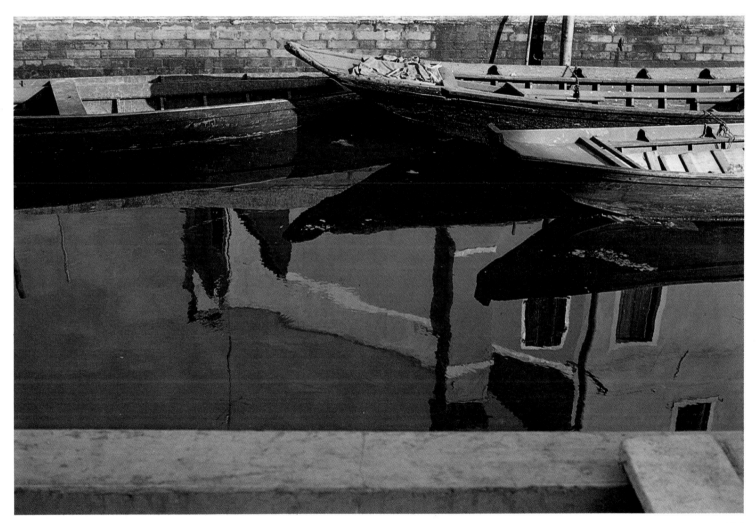

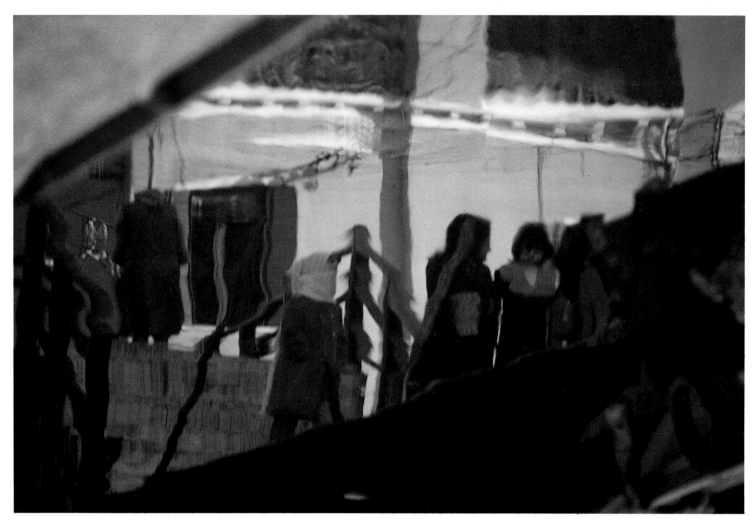

103

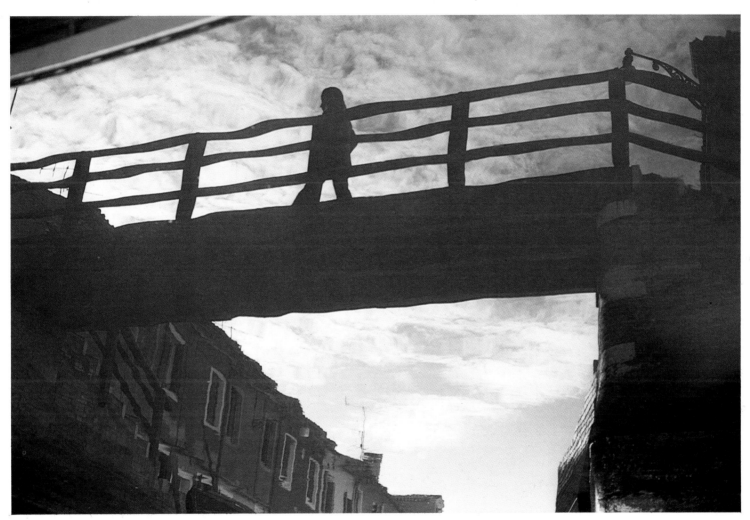

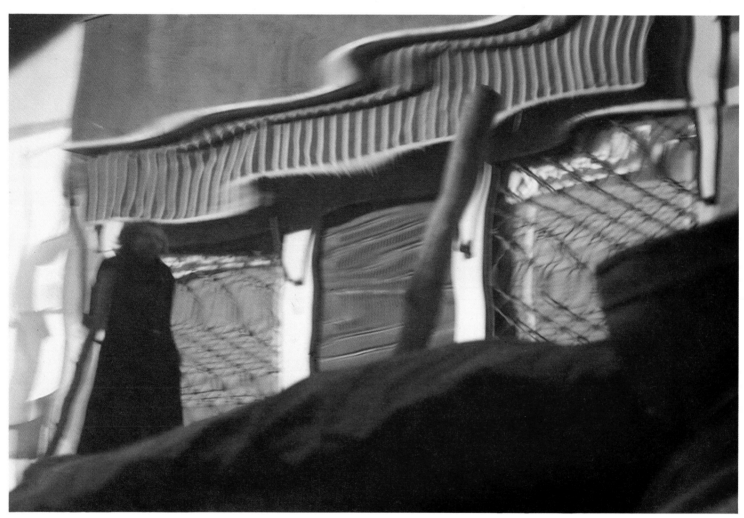

105

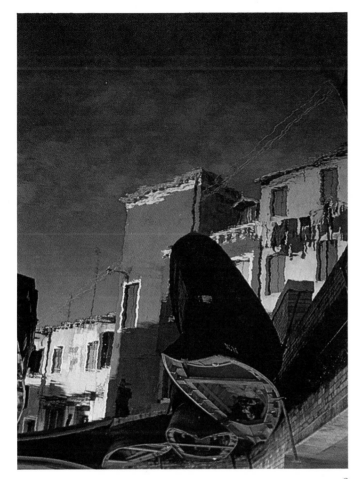

106

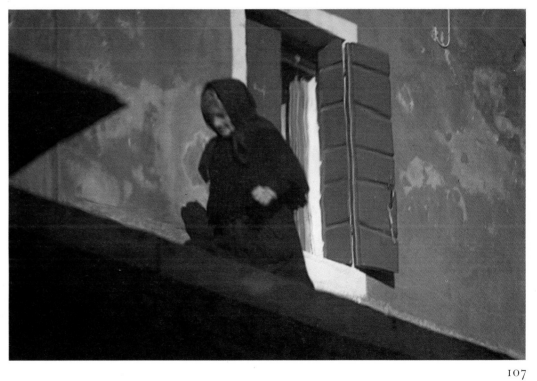

107

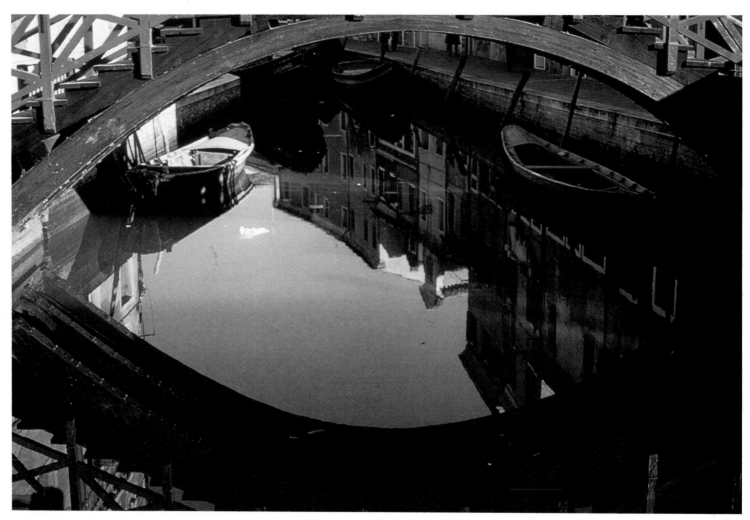

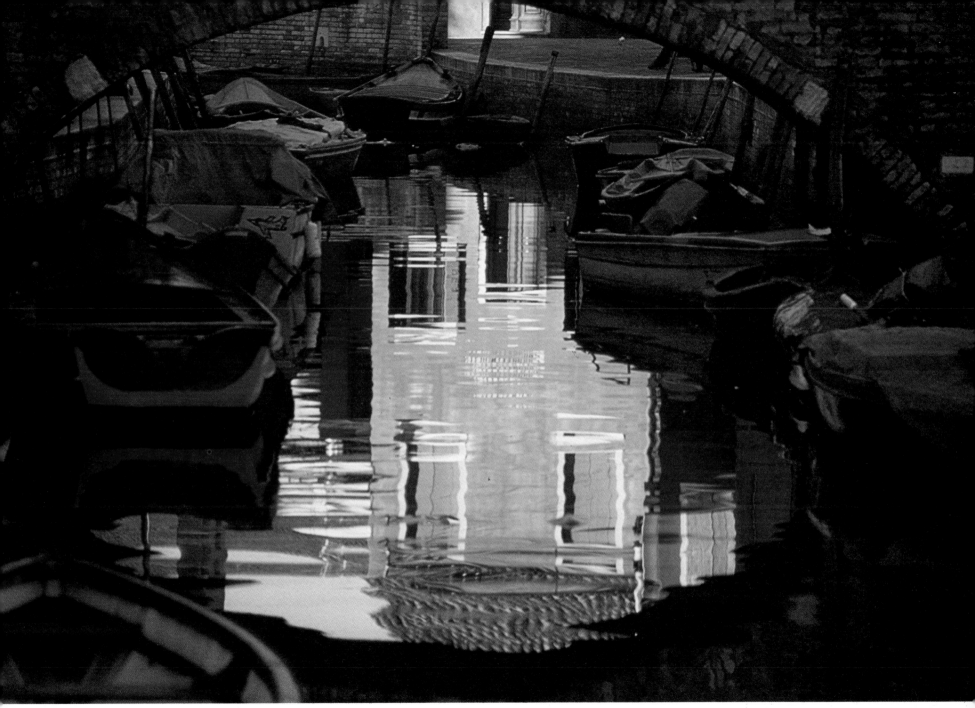

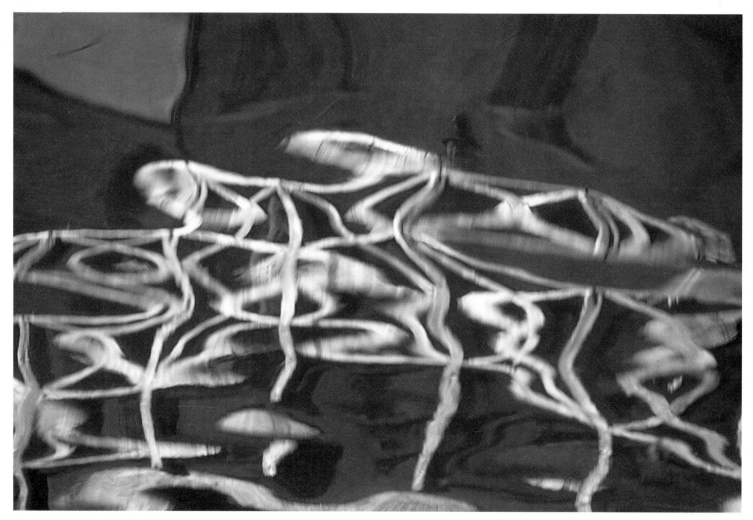

110

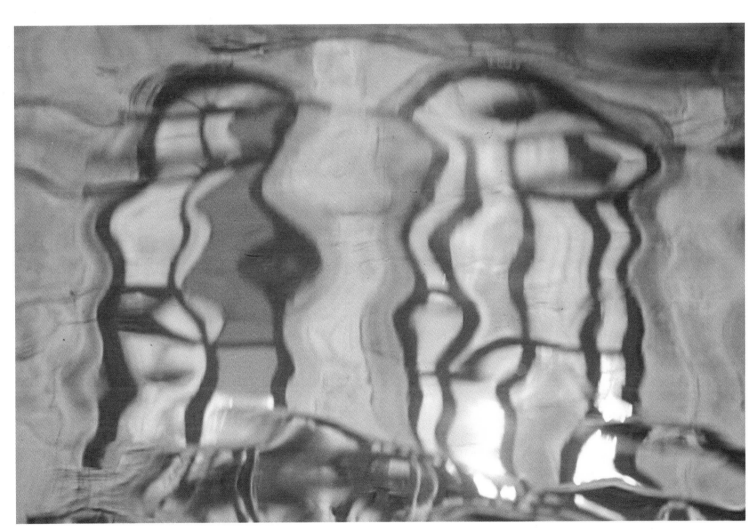

III

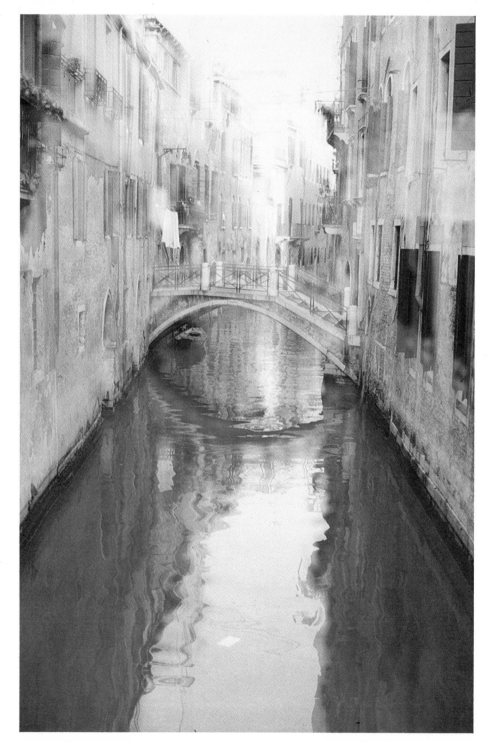

NOTES

Notes

Despite the wide variety of images provided by reflections, and the considerable experimentation that went into developing the techniques for photographing them, my equipment remained simple and consistent. I used two Nikon cameras, both of which I have had for over fifteen years. Although generally I carry four lenses, for this series I seldom used the wide angle or macro (close-up) lenses. I preferred the standard 50 mm (f 1.4) and a 200 mm telephoto.

All photographs were taken with a variety of Kodak 35 mm slide films. Whenever dim light conditions didn't prevent its use, I preferred the old Kodachrome II (ASA 25). It fitted my sense of color and produced what seemed to me to be accurate and natural colors. When Kodak withdrew Kodachrome II and substituted Kodachrome 25 and Kodachrome 64, I had to switch to and learn these new films. And throughout, whenever dim light conditions required it, I used High Speed Ektachrome, a flexible film, but with a narrower range of color tones. All processing was standard, done at Eastman Kodak, the film having been sent to them through a local camera store.

Familiarity with my films and camera equipment, gained over a period of many years, made their use almost instinctive. When photographing, I did not have to think consciously about exposure and technical details. Although I carried a Gossen Luna Pro light meter, I usually took only an initial reading and then made adjustments automatically as I perceived variations in the light. I later found out that my standard procedure was consistent with Zen philosophy; I became united with my camera and film,

and they became extensions of me.

In the natural flow of photographing I tended to bracket exposure and experiment with focus and composition, usually simultaneously. Sometimes, when things happened too fast, there was no chance, but whenever possible I tried subtly different interpretations—not as a consciously calculating process, but in a fluid, dynamic way more suited to moving along the streets than to the studio (and more suited to 35 mm than to larger formats). The technical data for each shot is therefore hard to reconstruct, but then I have never understood its relevance in nonstudio situations, which can never be precisely duplicated or reshot.

I can say that with my general preferences for slower film, I have often had to work with lenses opened up and/or shutter speeds as slow as 1/30 or 1/15, even having to hand hold the telephoto. Shallow depth of field is, in any case, inherent in reflections—one must almost always choose between focusing on the reflecting surface or on what is being reflected, usually some distance away. The inability to focus on both simultaneously I regard as a creative advantage rather than a practical limitation. The need to make a choice always provides creative opportunity, and varying the focus when photographing reflections can change the image entirely.

My simultaneous bracketing and experimentation with composition and focus also places a severe demand on editing— what I call ex-post-facto visualization. Composition and focus are intertwined and must be weighed and balanced together in order to select the right holistic result. The importance of editing is well

accepted in filmmaking where proper sequencing of images is the objective. But editing is no less important in still photography where the objective is choosing the right photographs from a series and making sure that all are of consistently high quality. Developing this critical ability is more important for free-lance photographers who have no client art director or editor to make decisions for them. And it is also important for those photographers working with slide film, which produces a positive image rather than a negative to be selected and later printed. It's hard to reject creations that seem so complete.

In my editing, I try to put myself outside the personal relationship I have with the photographs I have taken. The process takes a considerable period of time. I have to be able to live with the images, and I look at them repeatedly but at intervals. In trying to judge which works best, if none works best, they all go out. These photographs were selected from about 150 rolls of film, and even after several cullings I was left with several hundred from which to edit the final group. To a surprising degree, the more spontaneous and less studied shots, usually the first in a series, turned out to be the best.

When Clarence John Laughlin was looking at some of the photographs in this series, he exclaimed in obvious anticipation, "All these need are some good titles!" Yet I found it frustrating and overly directive to impose titles, whatever my creative flights of fancy, in order to match or support the imagery. So for the most part, I have retained the titles I originally gave the photographs simply out of need to identify slides during the editing process. The titles have stuck, and the dye-transfer prints I have made of many photographs in the series are now generally known by these titles. I would add only that while the titles often refer to locale and subject, the photographs obviously do not attempt to document specific places or things.

Reflections in street puddles were the first to catch and stimulate my imagination. On a film of water thinner in some places than the celluloid with which I transferred them were images deep and provocative despite their physical superficiality. By opening up a new world to me, these puddled images started me off on my quest for reflections, and I can't help thinking in this context of the Freudian associations of water with birth.

To photograph (midwife) these street puddle reflections, I evolved a series of techniques which I was able to adapt later to quite different reflections. In the beginning, while I was working in Piazza Navona, curious but unseeing onlookers would gather to puzzle over my stooping to aim my camera right at the ground. While this held people long enough to allow almost a type of reflected portraiture (6), I was more interested in establishing a sense of movement. And, consistent with my earlier yoga silhouettes, I was also interested in using people as symbolic figures, in this series, in relation to their environment (1, 2, 3). In order to accomplish this, I moved from the center of activity to the fringes of well-trodden routes where my photographing was easily disguised, or at least not so obvious.

Relocated, I was able to evolve a technique that was a combination of movement and still life, a blend of the previsualized and the unanticipated. Through the viewfinder, I concentrated on the reflecting surface in front of me and composed the photograph the way one would set a stage; then I waited for the actors to appear from behind, not knowing precisely where they would enter. In general, the focus is on something in the distance, and the surface is used for texture and framing. In some cases, however, I focused on the cobbles and waited for the movement of colors in the background (5).

I found as I experimented further that even a thinner film of water, such as streets wet with rain or the residue of a shopkeeper's swabbings, could offer mirrored images, recognizable if not altogether faithful (7, 8). Figures and shapes dissolve and merge, colors of objects are seemingly transferred and become attached to the medium of the pavement.

Given the fame and splendor of Rome's fountains, I naturally thought of them in terms of water reflections. However, I discovered that fountain pools are not as obvious a source of reflections as I had first supposed. The water pulsates and ripples and is seldom still. But instead of foregoing the fountains, I sought ways to use the energy of their spouting and splashing to produce reflections different from those I had first sought but in the end perhaps more appropriate (9, 10).

I came to see that other types of water, from the vast to the miniscule, could also provide intriguing mediums for reflected images. The Tiber, unlike the Seine in Paris, is neglected and relatively unused. In many places it flows too fast and is too clogged to be practical for commerce or recreation. Where placid, however, the opaque river acts both as an elaborate backdrop and a support for the silent soliloquy of movement acted out upon it (49). And when passing a window, I noticed arrangements of condensation, hundreds of tiny droplets, each one of which, upon closer inspection, acted as a separate lens, a disorderly compound eye like that of some strange insect (4).

Mirrors are the most obvious source of reflection. We use them every day for a variety of practical and narcissistic purposes, and they have long been accepted as decorative objects. But I was not interested in the more obvious and easily grasped images mirrors provide. I went searching for what mirrors could offer that I had not seen before—images that might be products of human craftsmanship, or by-products of human vanity and practical needs, but had never been intended in the mirrors' creation or normal use.

Images reflected in mirrors often remind me of motion pictures; when photographed, they seem to be still frames excerpted from films. The sense of motion is doubled by the viewer's changing perspective and the simultaneous movement of the reflected subjects. Reflections in mirrors seem to be natural forms of film montage—rapidly edited images provoking intellectual associations transcending time and space.

I found mirrors made, gilded, displayed, and sold along tiny streets which, with the presence of the mirrors, seemed to expand and reverberate (18). The rhythms are endless and carry far beyond that narrow way. More than present time is reflected in some mirrors. They appear to create nostalgic flashbacks to previous lives and dreams, framed, frozen by their own memories (17, 19).

Occasionally, the mirrors themselves are transported through the streets, a different type of cinema, projecting back what they also absorb (16). More commonly, however, they occupy a fixed vantage point as the world moves past. Some of the most interesting are those located at fulcrums of movement, such as blind intersections in small towns. Their bulging eyes not only give sight to what is around the corner but also, especially in sequence, choreograph patterns of light and movement (24, 25). In another photograph from a similar source (15), the woman has gone neither left nor right as the sign instructs, but ahead, alone, towards the light.

Sitting in a café one afternoon with some friends, I was changing my lenses in preparation to go out photographing when I noticed reflections in the lenses themselves. Keeping one lens between my knees, I used it as another kind of mirror to interpret the scene around me (22, 23).

My intrigue with mirrors led me to look also for other hard reflective surfaces, especially polished metal. The reflection of a giant poster in a silver plate inside an elegant shop window (14), or the reflections of umbrellas bounced back and forth in the burnished metal frame of a shop doorway (20, 21) are two examples from my search. The first reminds me of the stylized sets and ominous mood of the film *A Clockwork Orange*. If mirrors often seem nostalgic, the metal reflections seem futuristic. Their colors are more vivid, but also less precise, more abstract.

One can look into and through automobiles. And of course the reflections from the windows can also provide a simultaneous view of what is behind. Normally self-contained and seemingly impervious to and inconsiderate of their environment, automobiles get opened up and domesticated by reflections and thus become less self-contained.

Reflection photographs using vehicle windows to combine what is inside, in front, and behind look like collages and are therefore often mistaken for multiple exposures or sandwiched images (26, 28). Instead, they are what I call natural manipulations, and again, they depend on the ability to see, not on technical tricks.

In order to photograph these vehicle reflections, I adapted the earlier-developed strategy of setting the stage and waiting for the actors to enter or arrange themselves. I used the shapes of the car windows partially to frame what was beyond but also as dynamic forms in their own right, integral parts of the total composition.

Then I waited for what I could see happening behind me to fit the setting I had arranged. The results represent, among other things, the potpourri of activities that coexist in Rome's narrow streets. The relationships are not easy or stable, nor are they always harmonious, but they are fascinating to observe.

Buses by the hundreds brought the faithful and the curious to view the ruins and monuments, and again the juxtapositions intrigued me: the old and decaying with the new and aspiring; the static with the transient; that which had been officially sanctioned as worth seeing with what was usually best ignored. Tourist buses come to pay homage to what they themselves help to destroy. In several photographs (27, 31, 32, 33, 34), I used these vehicles to reverse the normal viewing process. Abandoned (or almost so) by their passengers off in search of prepackaged sights, the buses became a different kind of vehicle—a way for me to explore the phenomenon of observation and the relationships between the buses and their destinations.

After becoming attuned to reflections and after tracking them through the Roman streets, I also began to see windows and doors differently. Instead of passively looking through them to see what lay inside, as we are normally conditioned to do, I began to pay attention to the glass panes themselves and the reflections spread out upon them. Thus when I opened a door or looked into a window, I now found two environments revealed to me, the one inside, beyond, and the other behind, reflected. Often these two worlds, the one formerly shielded and the other excluded, visually merged, each taking on characteristics of the other.

In concentrating on window reflections, I began to notice and experiment with the ways in which the medium not only created reflections but modified them in the process. Every medium exerts its influence or personality on what it is transmitting, no less so with reflections. As the viewing perspective changes, windows or parts of them also change from transparent to opaque, thus altering substantially the nature of the juxtaposed images. When opaque, window glass becomes mirrorlike, revealing not only the external but also some features of the glass itself. Late afternoon sunlight striking old panes of glass, imperfect and irregular (36), produces color patterns and textures reminiscent of the technique and style of mosaics in which each tile is set at a slightly different angle in order to better catch the light. Imperfections in the glass of an empty display case also conditioned the reflections of the Spanish Steps (37) and produced the impressionistic rendering of one of Rome's most famous landmarks: The rhythms are repeated and the forms merge.

Plexiglass has even greater surface variations than glass normally does. It is thicker, less rigid, more rippled, and cloudy. Because it doesn't break, it is used in some of Rome's sidewalk cafés to shield patrons from breezes and fumes. I found the thick sheets a delightful medium. In the one example presented here (35), the swirls in the plexiglass pick up the colors from behind and fold them into a frieze of color which partially reveals and partially obscures the figures on the other side.

Reflections superimposed upon and partially surrounding figures vaguely visible through them seem sometimes to give visual expression to inner thoughts (39, 40). The man in the café door, his mind alert but his body suspended, pauses as if on the brink of some unknown. The woman waiting inside the door seems to have her thoughts projected, flowing out from her in ribbons of fantasy and expectation.

Parallel panes of glass often produce parallel reflections, each with a slightly different composition and perspective (41). Restaurant doors frame a man reflected twice, producing fraternal rather than identical twins. The cloudiness of the glass mutes the reflected image and diffuses the colors.

Where the surface of the glass offers few clues, it is hard to distinguish what is reflection and what isn't (45). The laundry in this photograph is outside the second-story window, the curtain is inside, and the part reflected is the blue sky deepened by the glass and given an intensity that belies the subtlety of the reflection.

Except perhaps for the Roman fountains, nowhere is water more celebrated for its aesthetic qualities than in Tivoli with its surging fountains and tumbling waterfalls set amid classical sculpture and elaborate architecture. Here water runs the gamut of associated emotions descending from turbulence to calm, ending up in a series of quiet reflecting pools. The photograph I have chosen from my Tivoli explorations (53) reveals the water's force and form but obscures its directions and origins. The slight distortion of the figures offers the only evidence of reflection.

Water is both utilitarian and recreational, and even when not avowedly valued for its aesthetics, it can still offer unexpected rewards in terms of reflected images. Water conveys many moods. When placid and opaque, it mirrors surface activity and the things around it, allowing colors to attach briefly and rest (46). And sometimes, when the depth or light is right, we can see beneath the surface (51), a combination reflection/refraction. By thus revealing itself, water establishes a dialogue with its surroundings, in this case a distorted, fanciful, even playful communication. Agitated, water disturbs the reflected environment, breaking figures into pieces and then putting them back together jumbled, creating new shapes and relationships (52).

In Milan, I found water images of a different sort. The mood of Milan differs from that of many other Italian cities. The scale is larger, the life more inner-directed and purposeful, the atmosphere colder. The wide streets and broad piazzas are paved with stones that are large, rectangular, and flat. Rain does not slide off to the side as happens with the Roman cobbles but remains on the surface, making the stones slick and deepening their somber colors. Piazza del Duomo is a huge void dominated at one end by the massive form and intricate detail of the cathedral. How to convey the mood of the city, how to use the broad surfaces of the wet pavement, and how to deal with the scale of the Duomo were all challenges I wanted to deal with. The two photographs chosen here (48, 49) reflect the somber determination of the Milanese. They reverse the scale of the human figures and the great cathedral, making the cathedral more accessible and emphasizing the craftsmanship of the detail as opposed to the commonly perceived mass.

Venice is timeless, full of fantasy and reverie. I became entranced with the city's mazelike alleys and quiet squares. When one is alone, walking along a narrow *calle* or emerging into an echoing *campo*, Venice is an intensely introspective experience. But along the banks of the larger canals and in the main squares where one is thrust back into the fast-paced crowds, Venice becomes a form of irresistible theater. I appreciate both moods. Watching all the activities of the canals, both the waterborne and those on the *fondamenta* alongside, one is conscious of the energy and vitality needed to sustain such a complex city. All the bustle of a major port is spread along its network of canals.

Riding the vaporettos (the water buses), became my favorite way of observing the life of the city. Although I quickly learned the various routes and stops, the incredible array of activities in and along the canals and the pace at which they all glided by— merging swiftly and smoothly—made each trip a totally new experience. The panes of glass in the vaporettos flashed images on and off like multi-screen slide shows, setting up provocative associations. Reflections from the vaporettos became a major interpretive medium for me. The best vantage point I found was on the back deck outside. From there, I could look inside, ahead, and behind simultaneously. I used the vaporetto's rear windows and doors to frame the composition. And I used the darkened forms of the passengers within to provide the backdrops for reflections in the intervening panes that revealed what was happening behind me in the water or along the banks. As the vaporetto moved, reflections were played across the bodies of unsuspecting passengers. In this case, I was on a moving stage, no longer waiting for actors to enter, but now actively seeking them out in brief auditions, then moving on.

The vaporetto reflections are thus combinations of movement, but ones which seem to belie their active essence, like the *adagio* in a *pas de deux*. Two in particular (54, 60) symbolize for me the introspective mood of Venice. In one, the solitary figure seems to represent subconscious quixotic existence transcending the corporal and temporal. And in the other, the woman's face forms the prow of the *traghetti*, which seems to be transporting the embodiments of her thoughts. The other vaporetto reflections (55, 56) also offer pensive juxtapositions of external forms and internal moods.

In the juxtaposed associations of window reflections, I found another medium through which I could interpret the disparate activities and dual personality of Venice (59, 61). In one photograph, the pattern of the cloth in the window duplicates the pattern of the old Venetian window glass while offsetting the commerce of the canal. The man links vitality and order. In another, a juxtaposition of a different sort is seen: the ultramodern superimposed on the ancient. *Woman Descending the Staircase* (57) reminds one of the cubists' amalgamation of form and movement. The form of the woman blends with the form of the balustrade, and each step of her descent remains visible.

Reflections do not belong to particular objects as do shadows; they owe their existence as much to the medium as to the subject. Their identities are lent and borrowed; they are never stable or predictable. Window reflections merge environments formerly discrete, inside and outside. Elements of each become visually superimposed upon one another, often in rapid succession, thus confusing origin and masking past identity. In the process, a series of entirely new relationships are created—jerry-built, perhaps, but provocative nonetheless. The permutations seem endless, and out of them come some that are symbiotic, self-sustaining in their new associations.

In many cases, distinctions between what is internal and what is external become blurred. The human figures, reflected or surrounded by reflections, partially obscured or superseded, turn ambiguous, ephemeral, caught between two worlds neither one of which is entirely real (70, 71, 72, 73). In the *Boy and Girl Reflected* (62), the two actors are linked by telepathy rather than proximity. The energy is mental, the dynamic is expectation rather than experience. Compositionally, the two figures are linked by the intricacy of the antique store reflections that occupy the space between them.

Sometimes the reflections are more subtle and act as backdrops of afternoon sunlight or shadow (63, 64, 69). And sometimes they become more involved, depending on peculiarities of the medium itself—whether parallel panes of glass, each one of which claims its own image (67); a closing door in which the reflections seem to vibrate (68); striped windows partially masked with highly reflective paint (75); or double-thick panes each of which produces its own reflection, stacking them on top of one another unevenly so that, in the photograph, the figures seem divided (74).

Vehicles in the smaller Italian towns tended to be drawn up around the major centers of activity—the piazzas, the markets, and the churches. They seemed more patient, more at ease, less alarming. At the end of the day they withdrew. They were less ubiquitous, more individual, and therefore more noticeable.

While I was resting in the main square of Perugia one afternoon, a sleek sports car parked nearby. The passengers got out and left, and after a few moments when I too felt like moving, I walked by the car and casually looked it over. When I got close enough, my wandering mind snapped to attention with the sudden perception that the front of the car contained, unknown to the owner, I am sure, splendid surreal images, clouds, and medieval walls superimposed on the metallic sculpture of the hood, reminding me of a Magritte painting (76). The photograph produces so much fantasy and speculation that I usually hesitate to reveal its precise origins.

In other vehicle reflections, I continued the technique originally developed in my puddle reflections and later adapted to cars—that of combining the previsualized stage setting with the spontaneity of the unconscious actors. Consistent with my earlier series of cut photographs in which I sought to make the borders of the photographs part of the composition and not merely the container, in these reflections I used the vehicle forms as active compositional forces. I was able to do this in a variety of ways. In one illustration (80), the setting is a fuguelike interplay of forms and textures between the car seats and the reflected building arches. The women with their children enter to the twin themes, seeming to link past with future. In another (78), a collage effect is again created. In this case, however, the parts of the collage do not overlap but coexist side by side as in some of the photograms-cum-drawings of Moholy-Nagy. Both the man and the void, seen through the vehicle, also interact with the reflected environment. Telephone lines connect all the various parts in circular dialogue. And man's passion for the automobile, whether as an aesthetic object or psychological extension, is represented in another reflection by superimposing the human and mechanical forms (84).

Traveling to Sicily for the first time in many years, I vowed to return to Agrigento to see, not necessarily to photograph, the magnificent Greek temples so gracefully situated between the mountains and the Mediterranean. After spending most of a day getting reacquainted with the ruins, I went back to my rented car prepared to leave—and for the first time noticed the reflections of the temples in the car windows. The juxtaposition of the classical columns and temple outline with the modern interior of the car (81), seemed in that context to suggest further questions about time and progress and ancient versus modern aesthetics. Another reflection (82), also taken of an Agrigento temple in my car window, bespeaks the impending struggle for survival on the part of what little of the past we have left. And a third (77), looks back one last time to what someday may be nothing more than a memory.

When I first began traveling through Italy in search of new reflections, I felt like some kind of reverse archaeologist bent on unearthing not the enduring but the fleeting. Reflections are impermanent, and each is personal, dependent on one's individual perspective. Reflections are thus malleable, and part of the intrigue of photographing them lies in their great responsiveness to subtle adjustments in focus and framing. Changes in perspective resulting from even slight body movements, forward, back, to the side, or up and down, can produce remarkably different images—a fine tuning exceeding that normally available in photography. And switching focus from the source to the reflecting surface in combination with compositional changes also contributes to producing totally different photographs (86, 87, 88).

I became curious to know the range of reflections I would find in my explorations, and how different they might be from one place to the next. I found that even windows, those seemingly standardized surfaces, produce widely varying reflections depending, at least in part, on locale. Reflections can be interpreted as indices of activity and scale. In general, the smaller the town, the fewer the reflections (i.e., the right combination of available surface and suitable activity). In the smaller towns the central piazzas are the focus of town life; here the town's religious, social, and economic activities come together. Towns such as Spoleto or Orvietto are still dominated by their main squares, around which are clustered shop and store windows, normally silent spectators to the changing scenes. The glass surfaces are also different in smaller towns, usually smaller in scale and sometimes older and imperfect. Reflections taken in old-fashioned window glass (90) often produce impressionistic renderings, making one wonder whether the impressionist painters drew inspiration from the glass surfaces around them as well as from water.

In the larger towns, the piazzas are still the public gathering places, the points of greatest activity and interest and frequency of reflections. In cities like Florence and Pisa, a large part of their activity is now provided by tourists, alien but integral. As a result, the piazzas are now ringed by modern establishments designed not to enhance the ancient treasures already there but to entice new wealth. In Florence, I photographed a festival celebration staged for tourists, witnessed by a copy of Michelangelo's David, cheered by thousands, and paid for by BankAmericard—all reflected in the modern glass door of a café on the periphery (96). In Pisa (92) I merged the real with the fake, confusing not only authenticity but also scale and stability. In Milan, the windowpanes are larger, the street wider, and the activities more spread out. Within this larger scale, window reflections seemed best used to celebrate small details rather than major themes. Two examples from Milan (93, 94) cradle or encompass the pinnacles of the endangered but resilient cathedral.

"To photograph pure light must be an exciting thing," my friend Sergio used to tell me. I began to understand what he meant when I discovered in a modern store swirls of clear reflected light that seemed to rise genielike from the magic kettle (95). I included the woman because I wanted to bind my fantasy to the real world where in the end it must be perceived.

I went to Venice early in this series naïvely expecting that where there was water, there must be reflections. But the canals proved so large and choppy that the light reflected did not provide recognizable images. It was as if the reflections I felt sure must be there had sunk. Only in the small back canals did it seem possible to photograph reflections, and then it was a challenge to escape the ordinary, the inadvertent cliché. I have kept only two from my first explorations, each for a different reason.

Venice Canal (112) is a celebration of Venice and what it means to me—the quintessential Venice photograph. Most people seem to associate Venice with morbidity or struggle, and I have never understood why. To me Venice is a city of fantasy, of mystery and grace—and where there is fantasy, there is hope and the essence of life. I must confess that I do not remember taking this photograph, not even where I was. It was an isolated shot, with no preceding or subsequent attempts to experiment—spontaneous, instinctive, lucky. If the exposure were "correct," it wouldn't work.

In a fantasy of a different sort (111), consciously chosen because of the associations it produced, the classic forms of the old windows were transformed through the distorted reflection into modernistic forms reminiscent of the sculpture of Jean Dubuffet.

Someone, I don't remember who, told me to go to Burano ("not Murano, Burano"), a small fishing village off the coast, and when I did, I discovered canals that could indeed be photographed and reflections that far surpassed my original expectations. The rest of the photographs in this section were taken there on a succession of quiet Sundays when the canals were placid, the people at rest, and (especially for the occasion, it seemed) the winter sun shining. The houses along the narrow canals are painted different colors, a living palette for the photographer to use.

One strong fascination with photographing water reflections is the resultant disorientation and creative confusion. In calm water, normal distinctions—distinctions that attempt to separate the real from the illusory, the original from the copy—become obscured. What is right side up or upside down also loses meaning, and thus I feel it appropriate to print the photographs in the way they work best, not necessarily the way the scenes existed before photographed. Some seem to work equally well either way; *Red Boat, Burano* (97) merges the original and the reflection to a degree where it is no longer relevant to speak of the real and the illusory. The graphic composition is continuous, so that appreciation does not depend on identifying the subject matter or on viewing it in one prescribed fashion. I have collectors

who prefer this "upside down" and have asked me to sign it that way.

By reversing the reflections, other photographs consciously call attention to the changed perspective and new relationships thus revealed. In these views from the water upward, the familiar orientation of some elements is belied by the reversal of others. The blue boat in one (99) no longer floats but hangs overhead, now intruding upon instead of uniting the seemingly normal life along the canal. And in the other (106), the boats improbably float upside down beneath tranquil skies in a conscious reversal of normal spatial perceptions. The picture plane becomes flatter and instead of merely seeing objects in space, the emphasis now shifts to pictoral elements such as composition and form, and we see differently as a result.

In many cases the interplay of reflected and nonreflected elements is striking even without the reversals. I found that the arched bridges over the canals mirrored in the water could be used to frame the dialogue between the canals and their surroundings (108, 109). Both remind me of eyes with unusually shaped and colored pupils.

These Burano reflections vary in the moods they convey from the placid pastels (102) to more disorderly and vibrant colors caused by slight disturbances in the water (101, 105). The disorientation and creative confusion of agitated water create a quite different mood from that of calm water. Sometimes the variegated colors of the adjacent houses graphically tumble together into the canals, a visual humpty-dumpty that challenges reconstruction (100). But in some cases the distortions are barely noticeable, offering only slim clues to the nature of the medium, such as slight distortions of human figures (103) or bent shutters (107). The disturbed canals can also be ambiguous, combining the graphic with the somber. In (110), the dark background of the water and the half-obscured figure of the man hauntingly offset the graphic quality of the old intricate wooden bridge washed by light. At a distance, the graphic predominates, but upon closer inspection, the mystery of the human figure asserts itself.